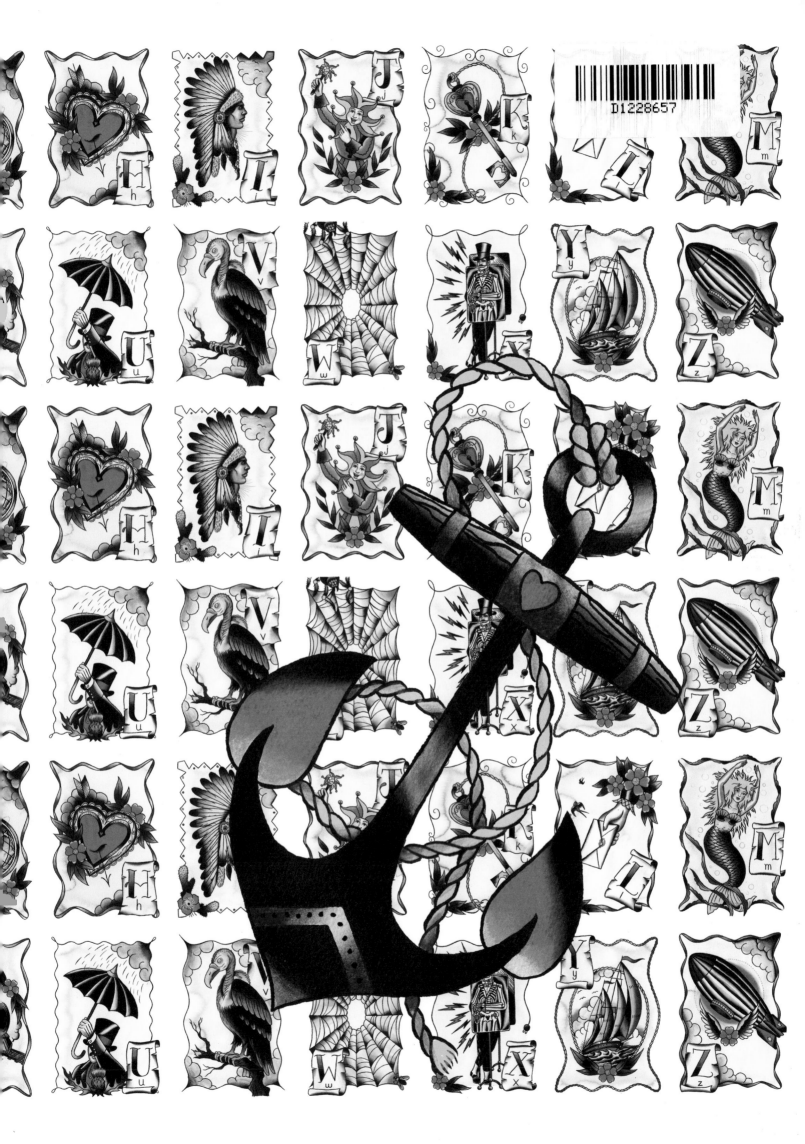

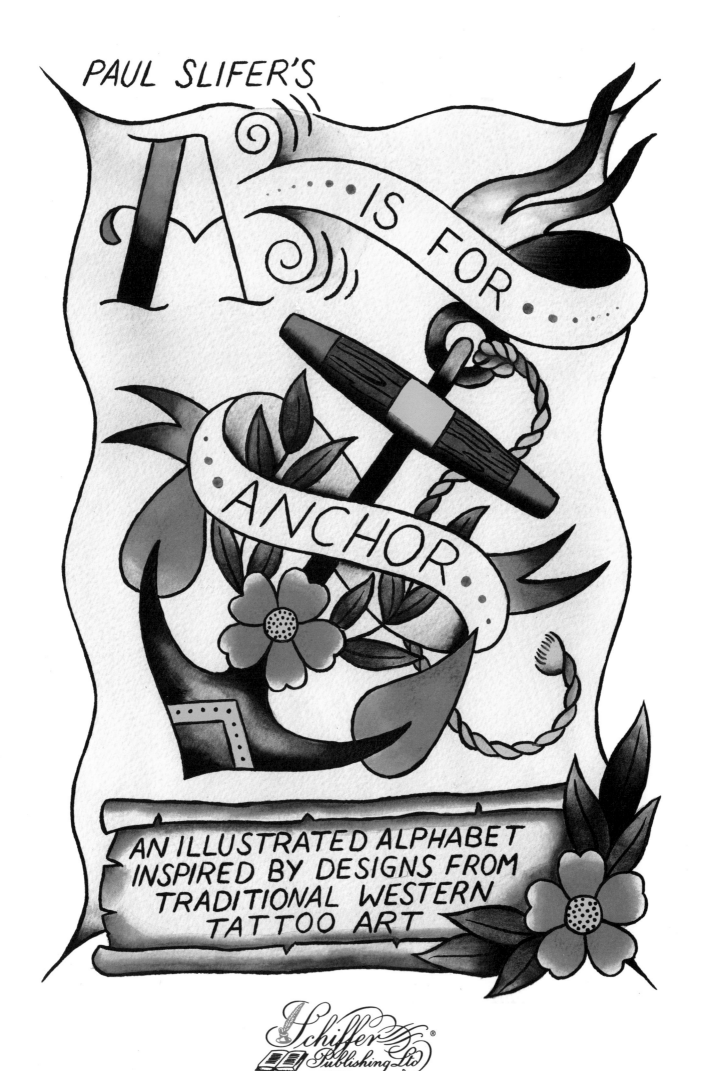

PAUL SLIFER'S

A IS FOR ANCHOR

AN ILLUSTRATED ALPHABET INSPIRED BY DESIGNS FROM TRADITIONAL WESTERN TATTOO ART

Schiffer Publishing Ltd

4880 Lower Valley Road • Atglen, PA 19310

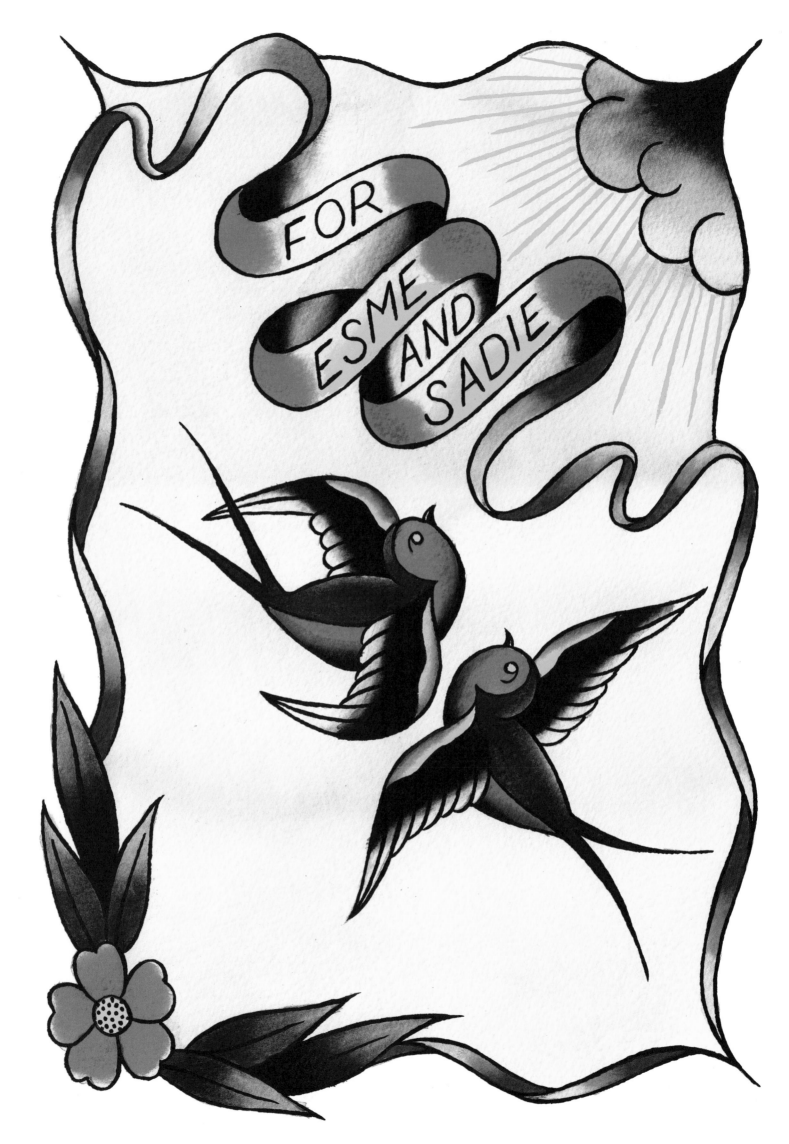

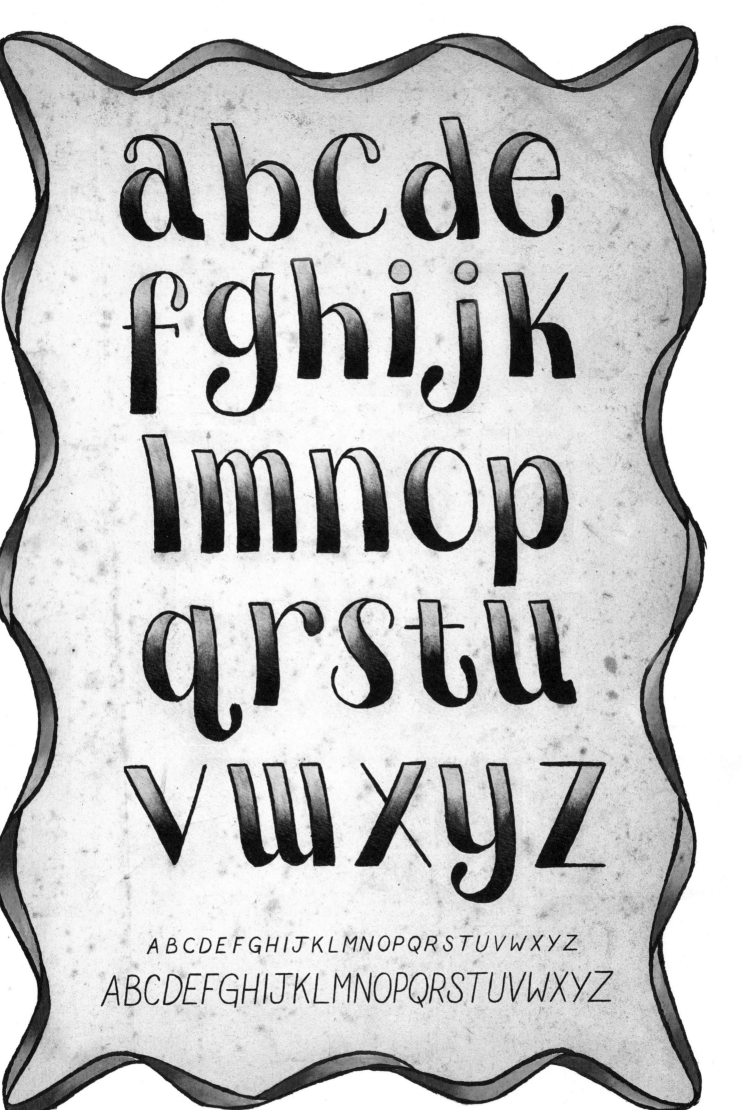

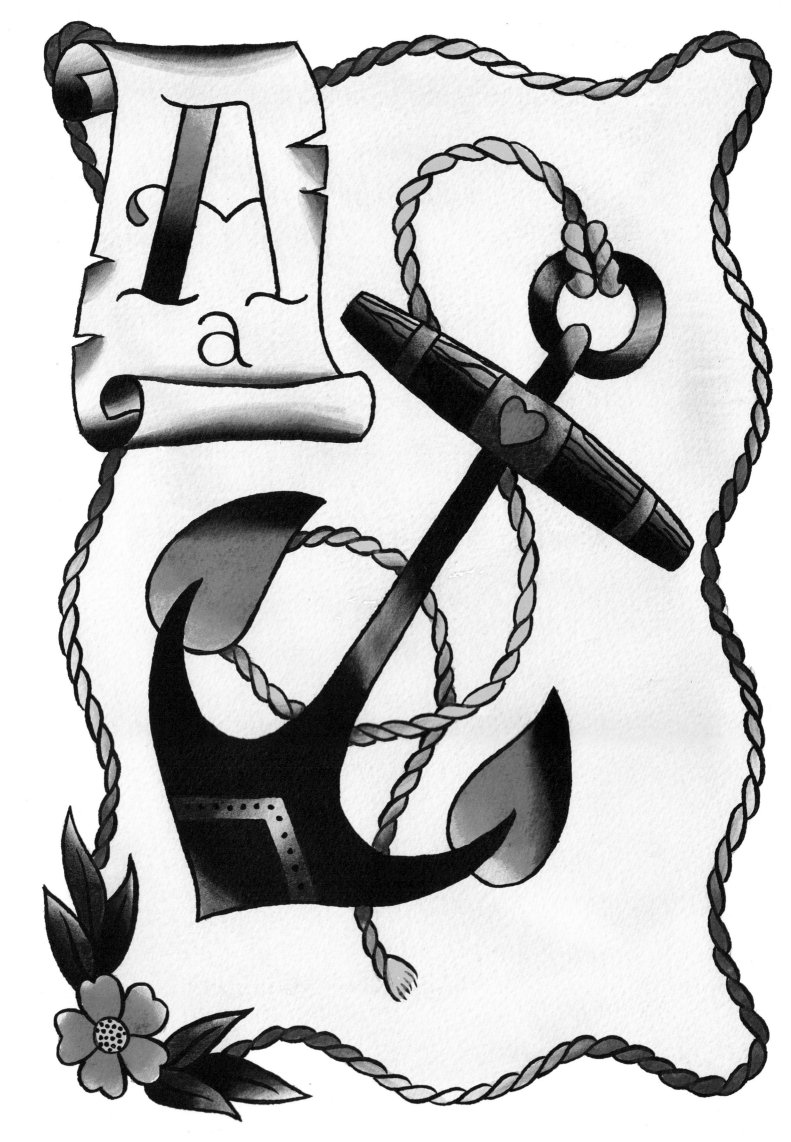

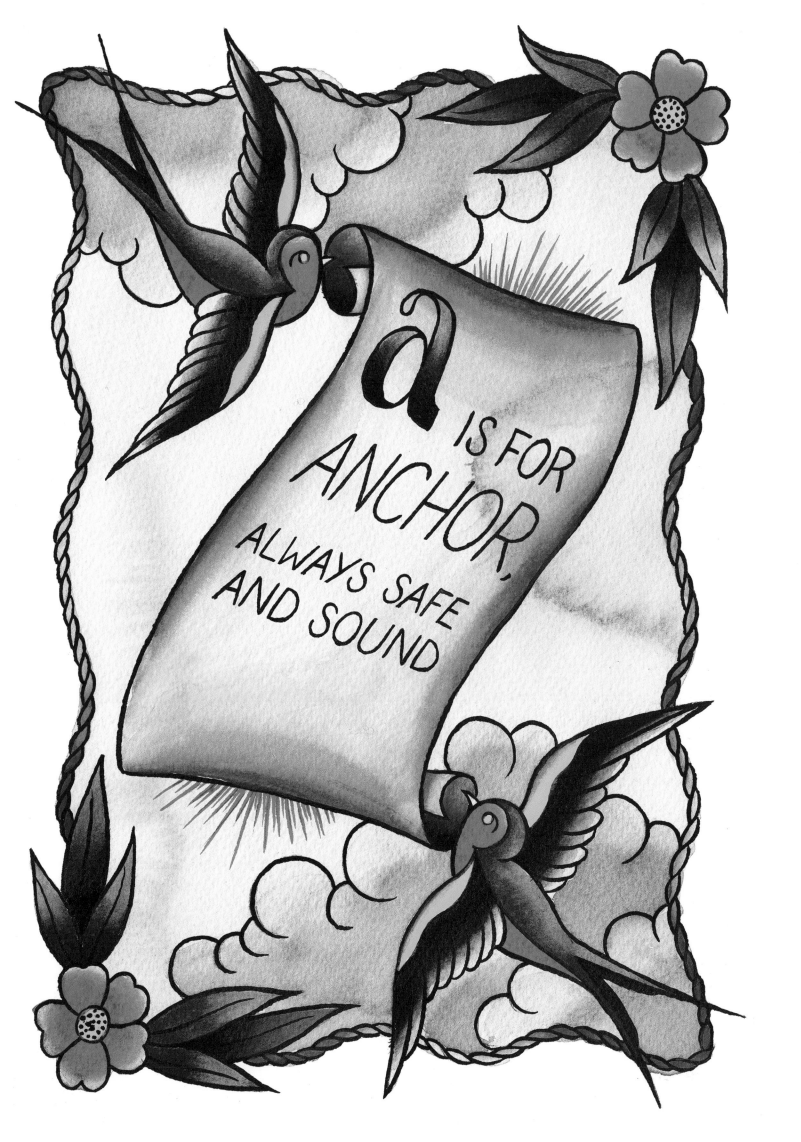

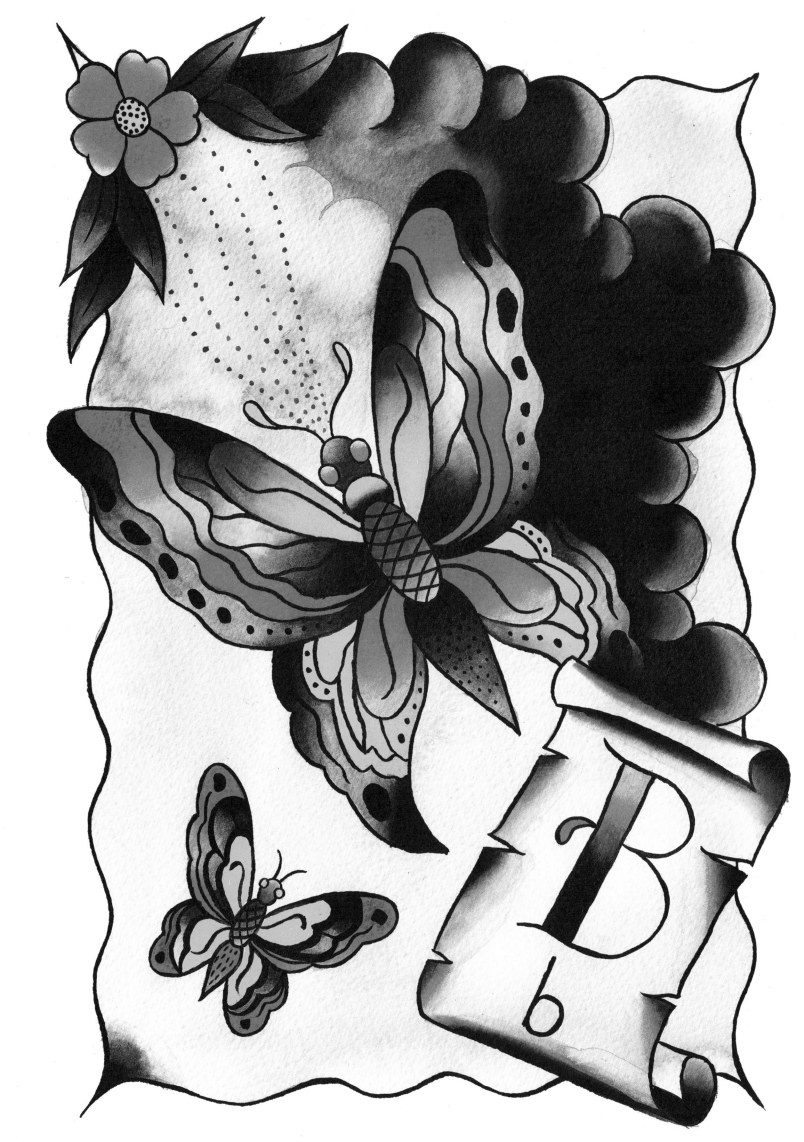

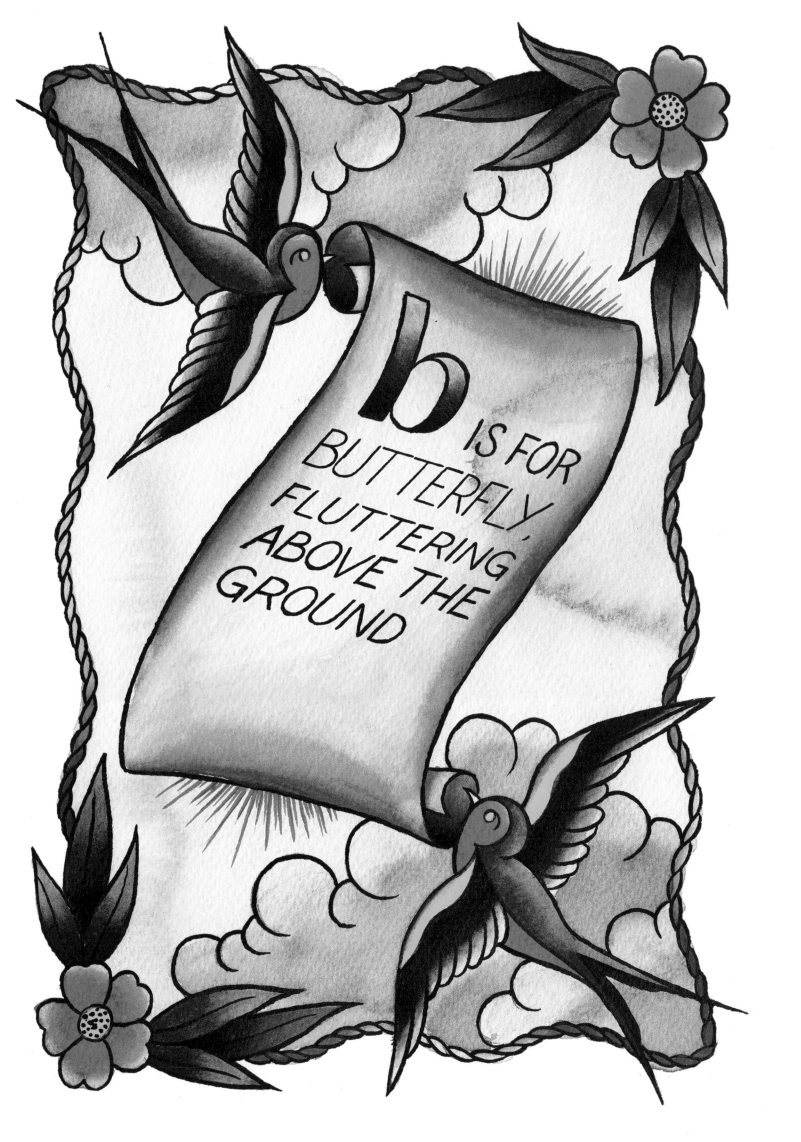

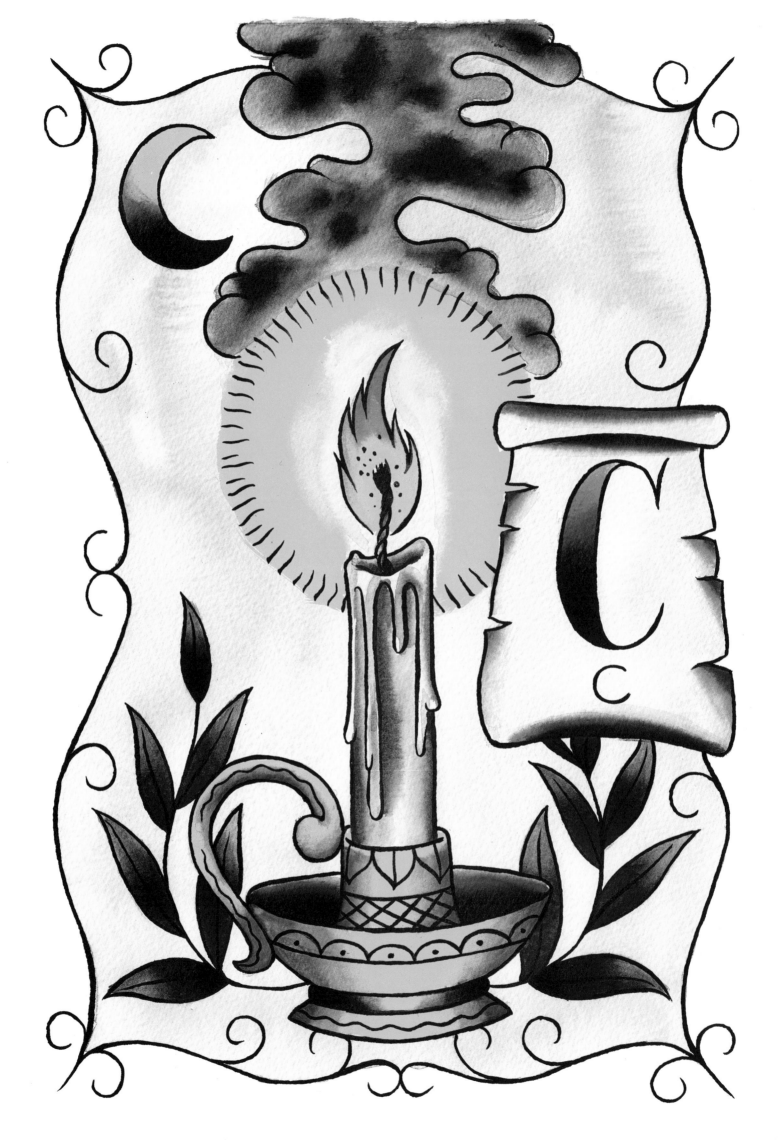

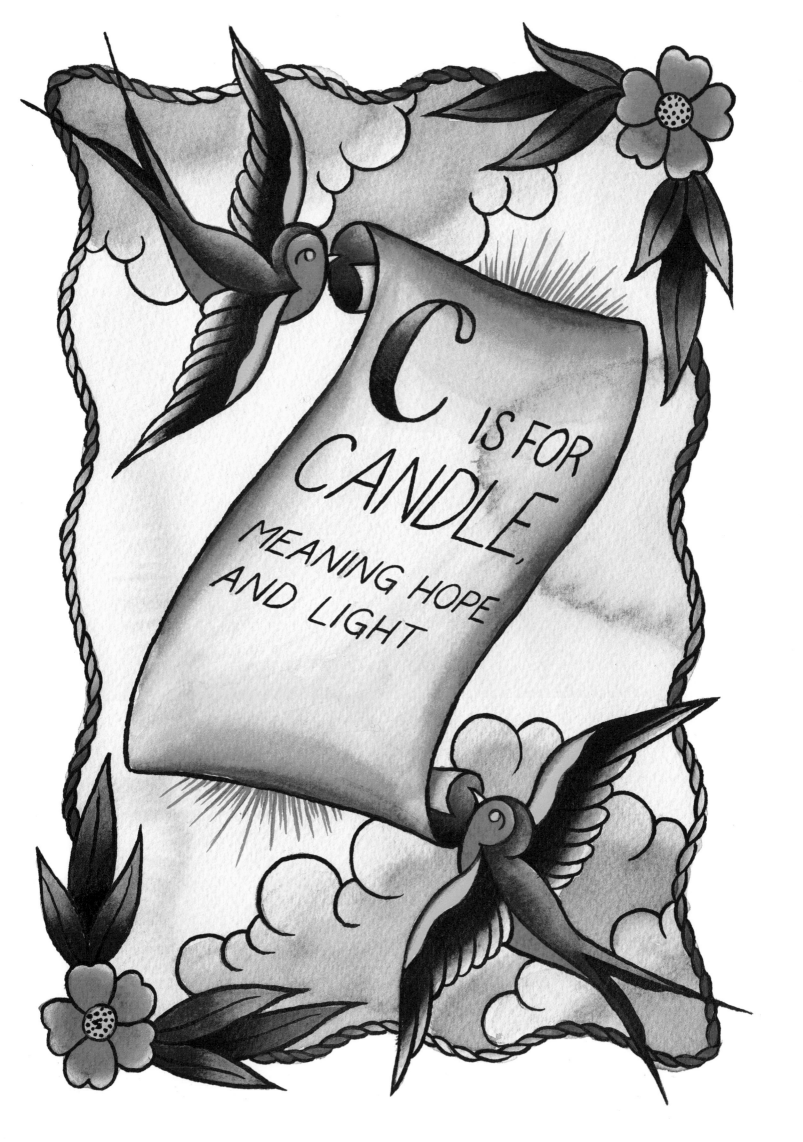

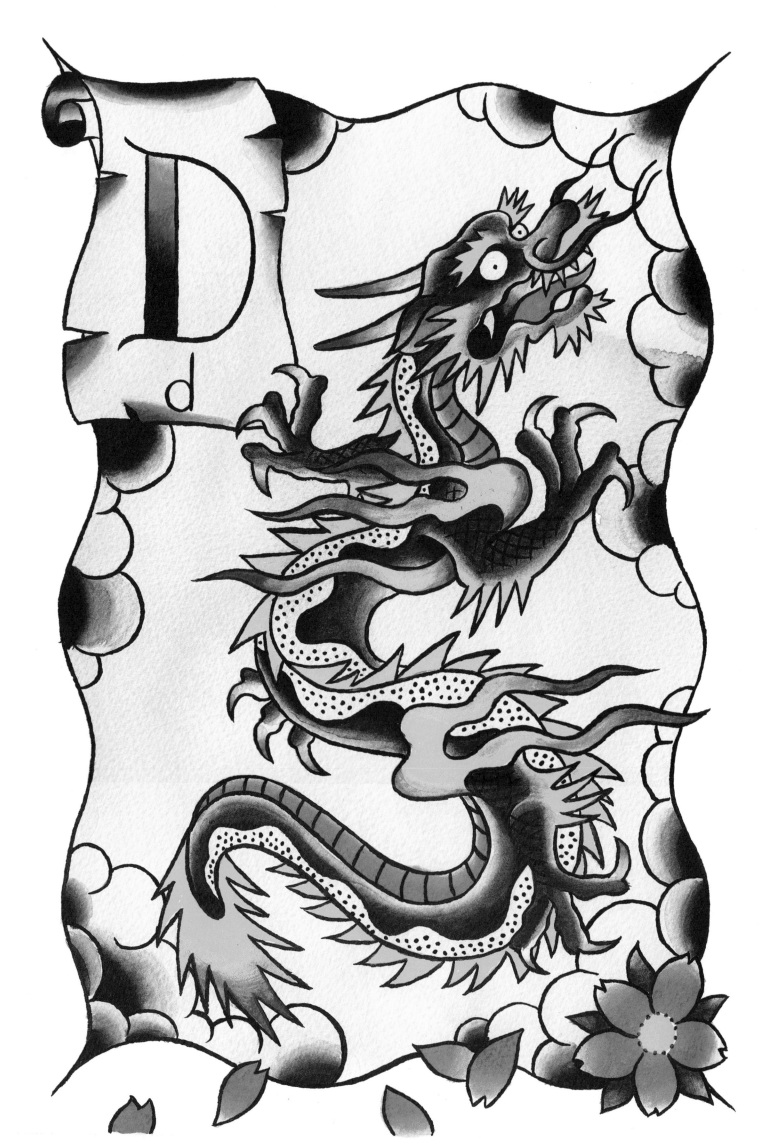

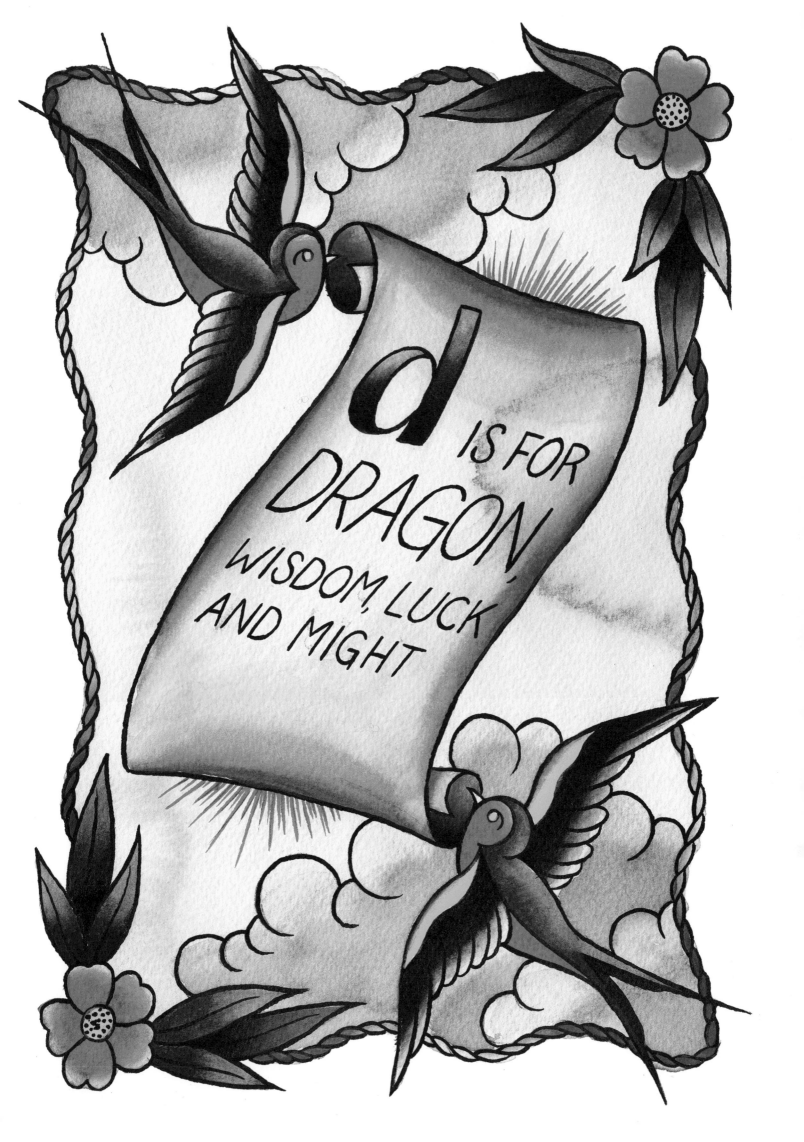

d IS FOR DRAGON, WISDOM, LUCK AND MIGHT

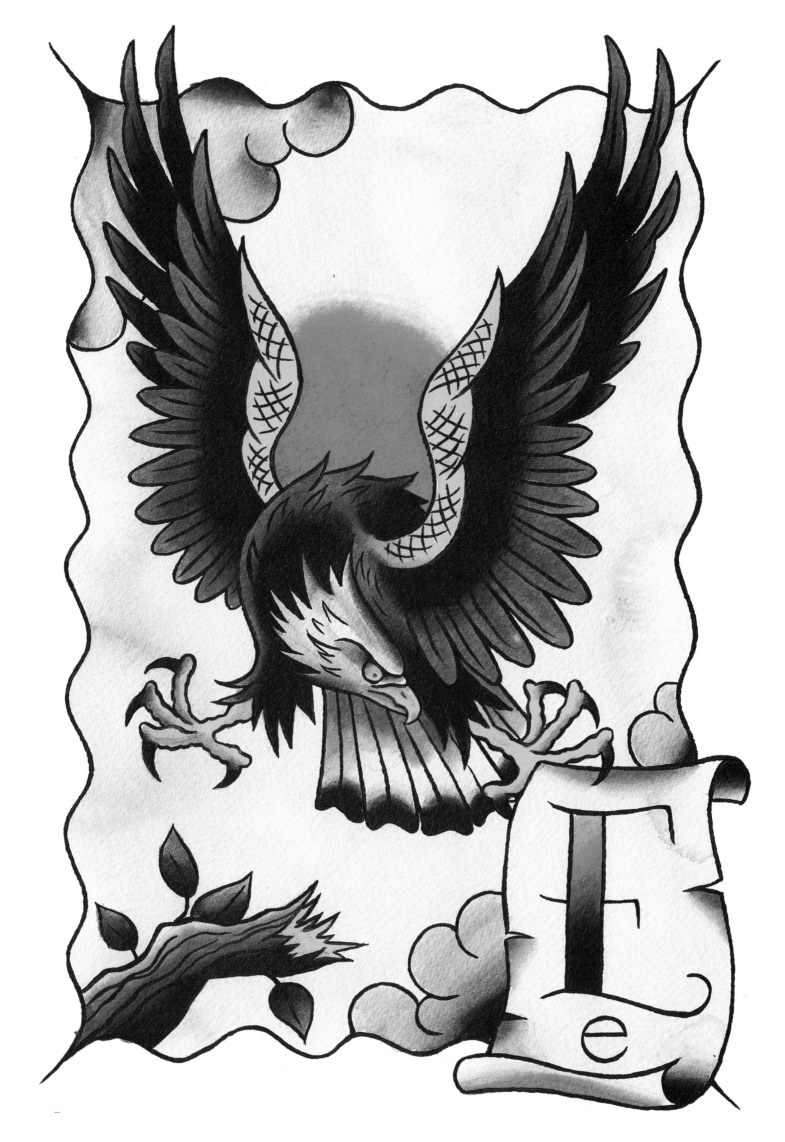

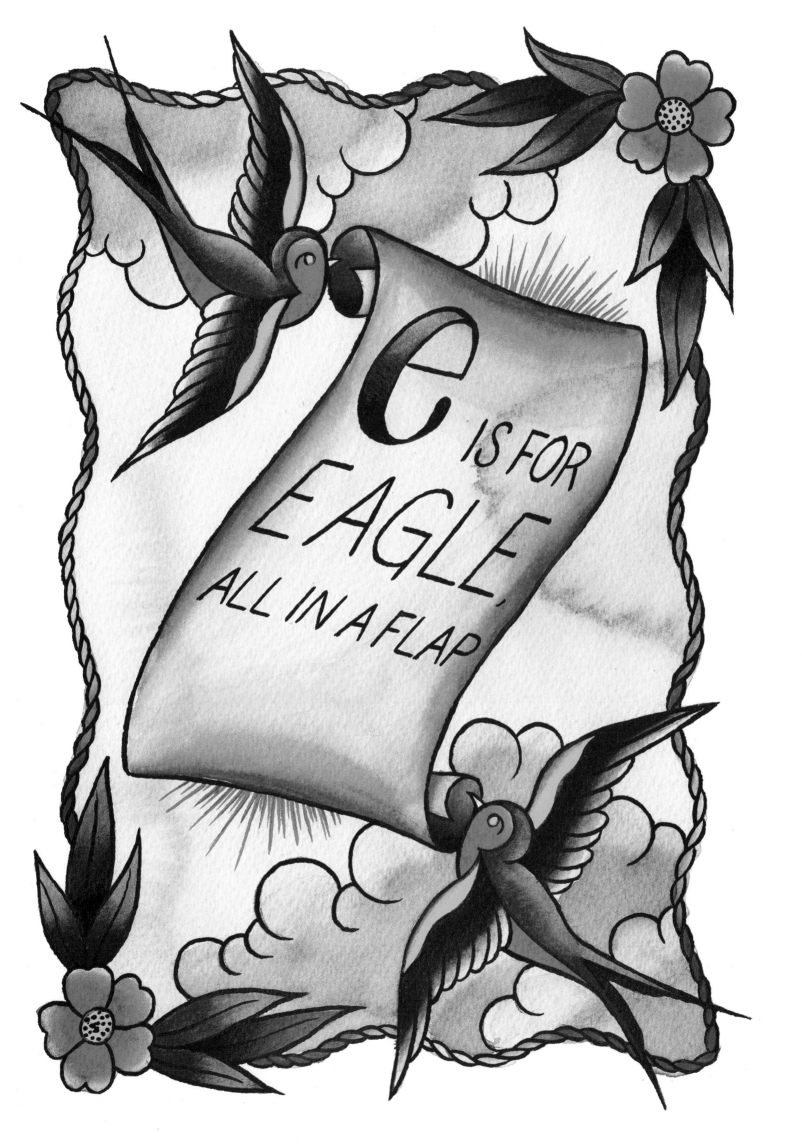

e IS FOR EAGLE, ALL IN A FLAP

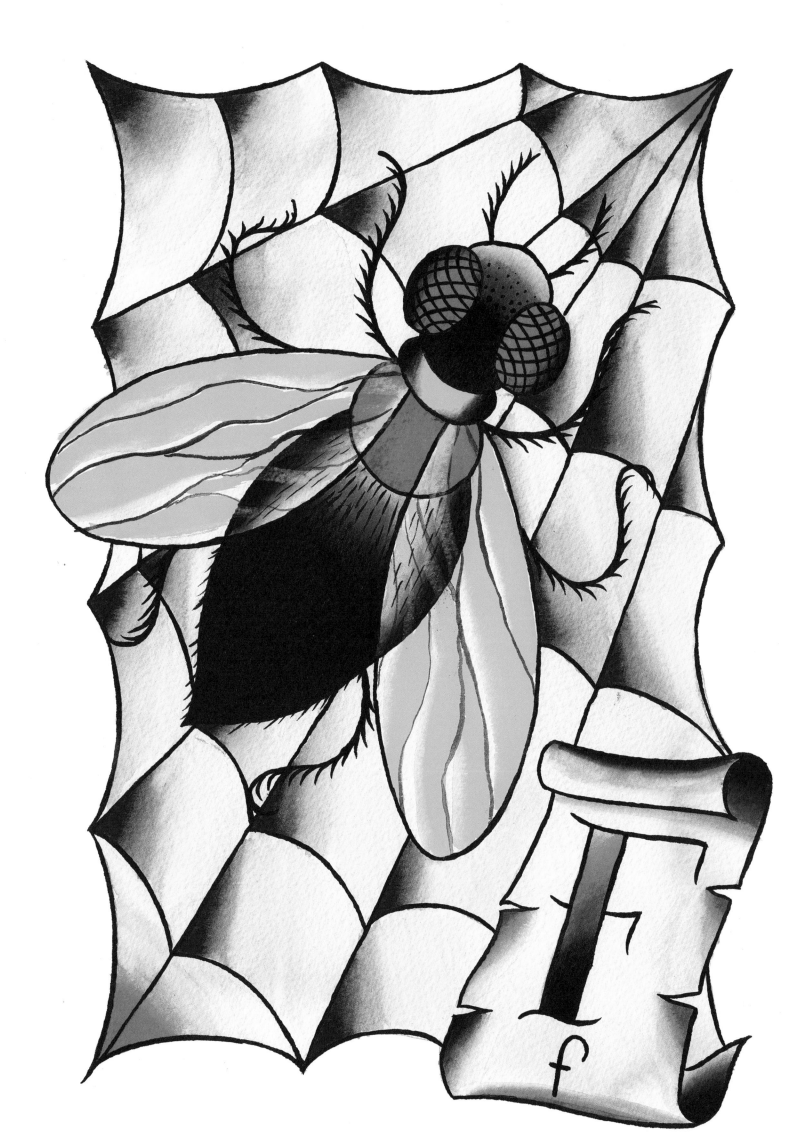

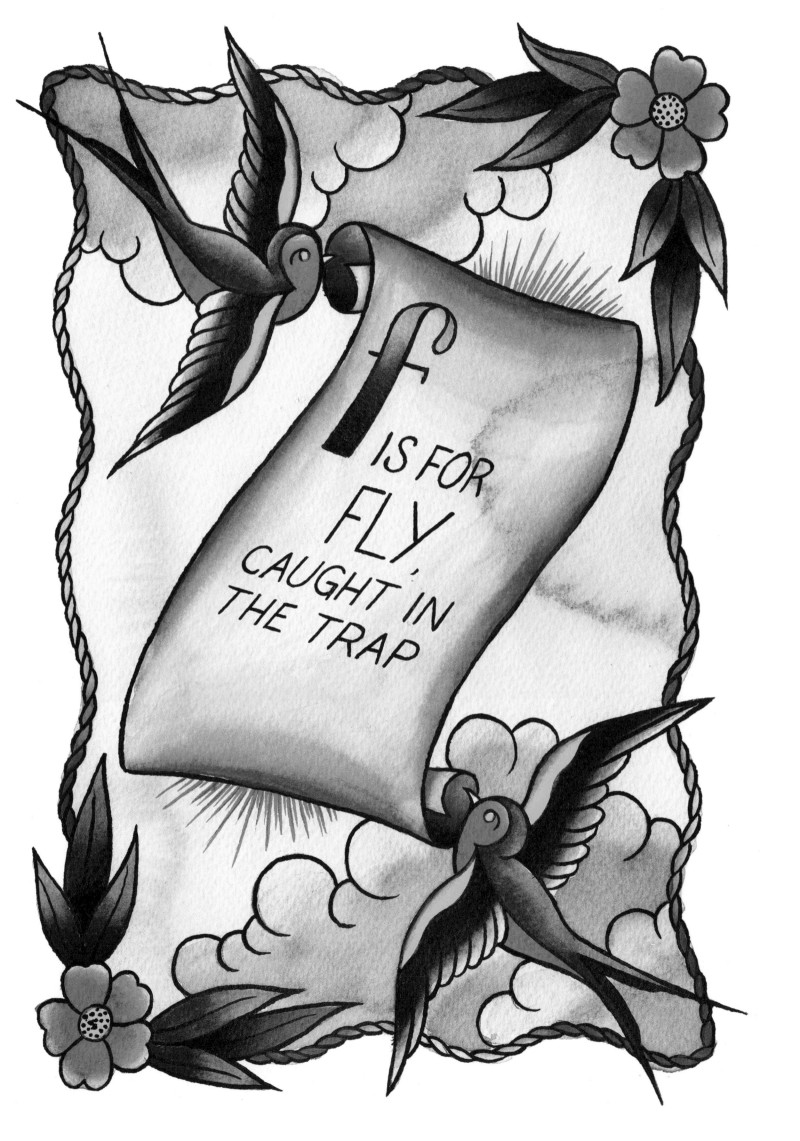

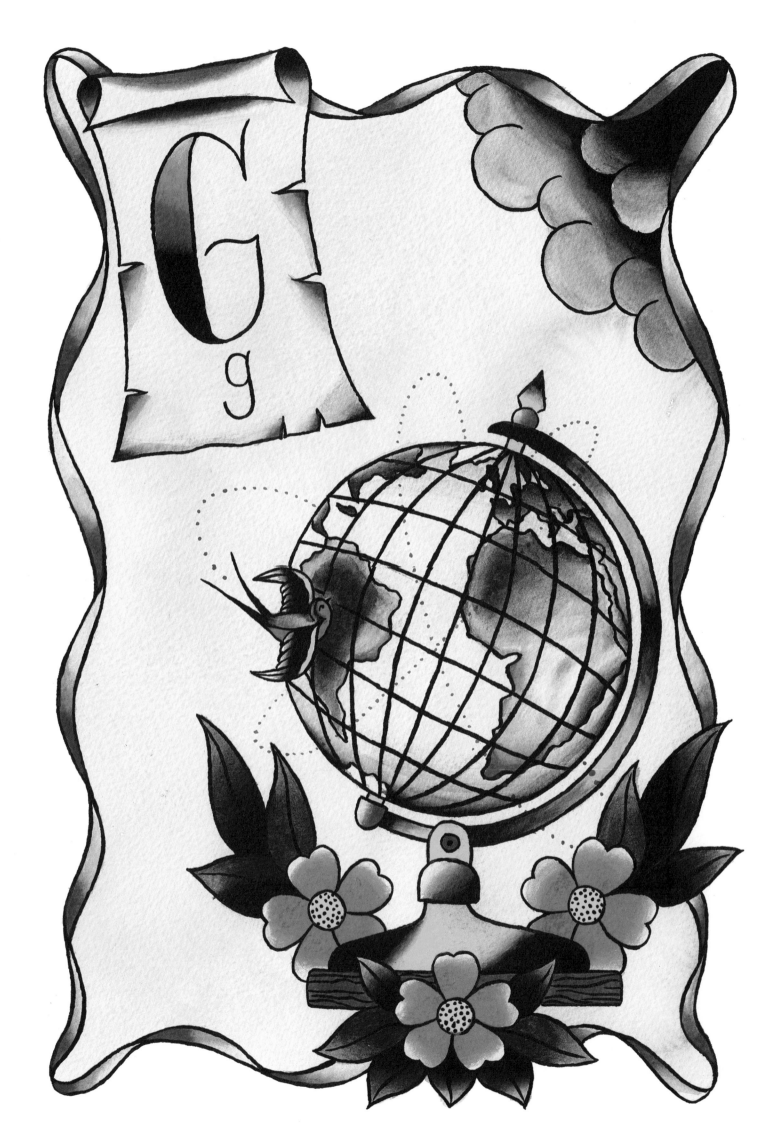

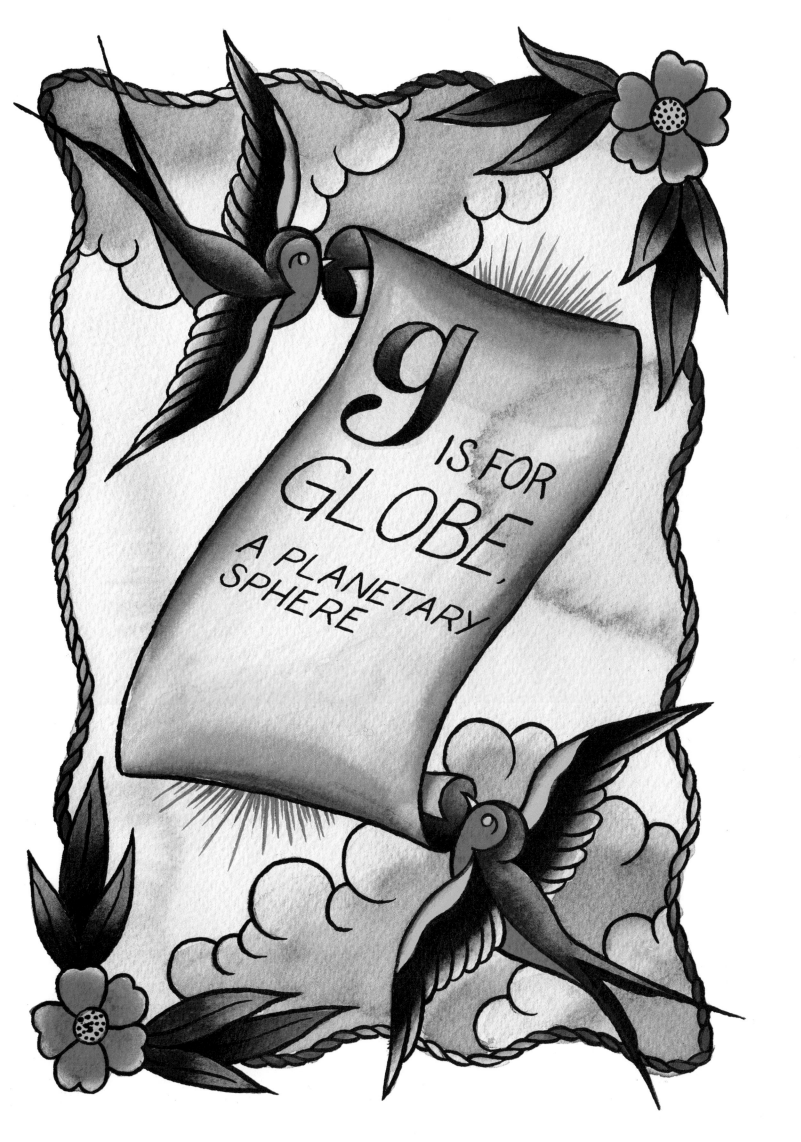

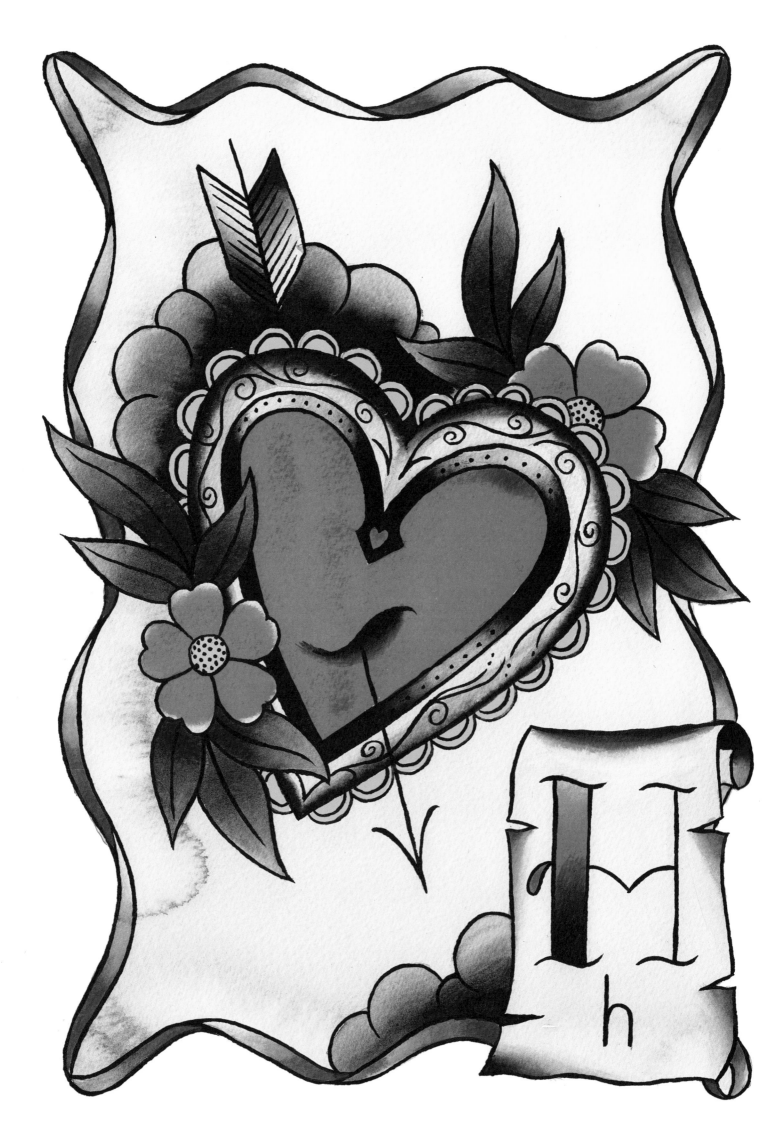

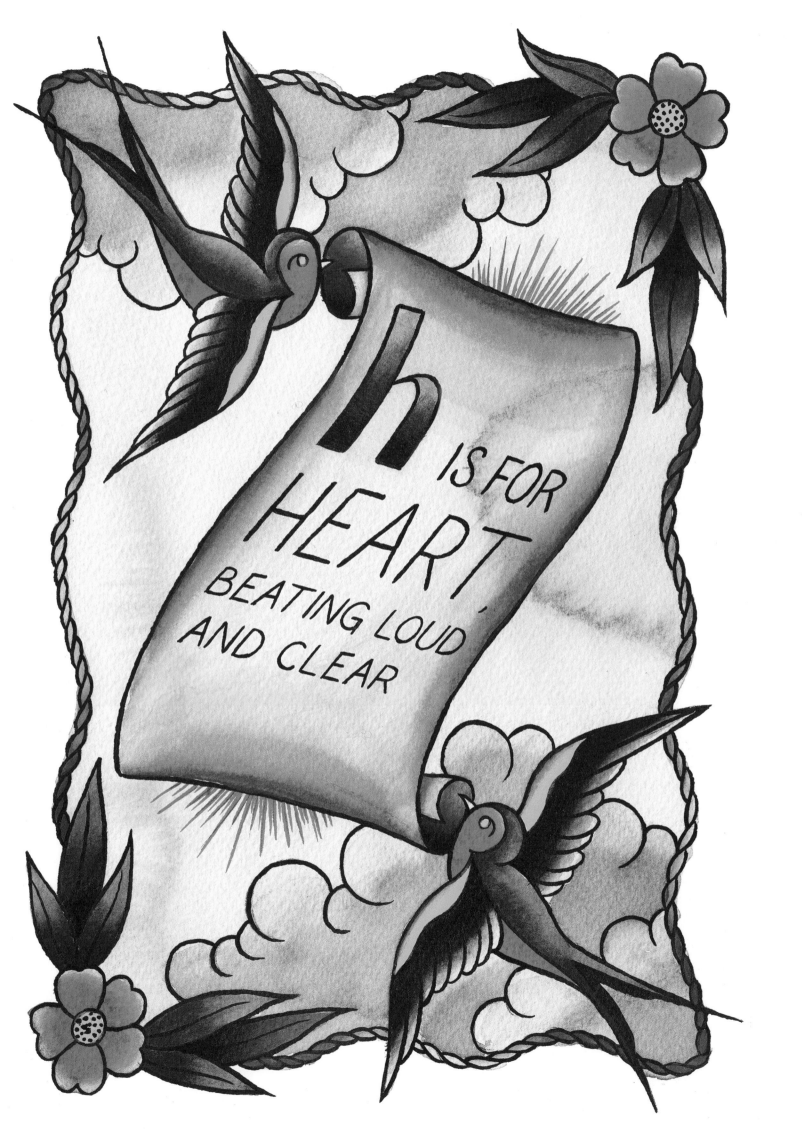

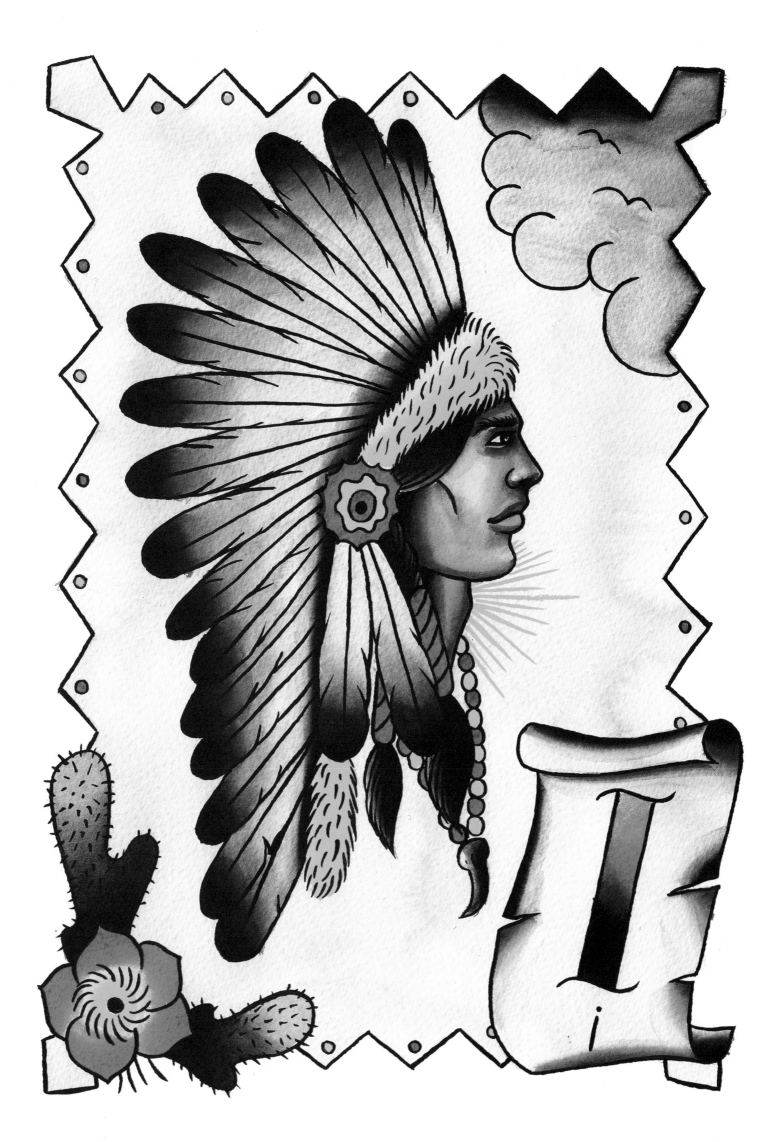

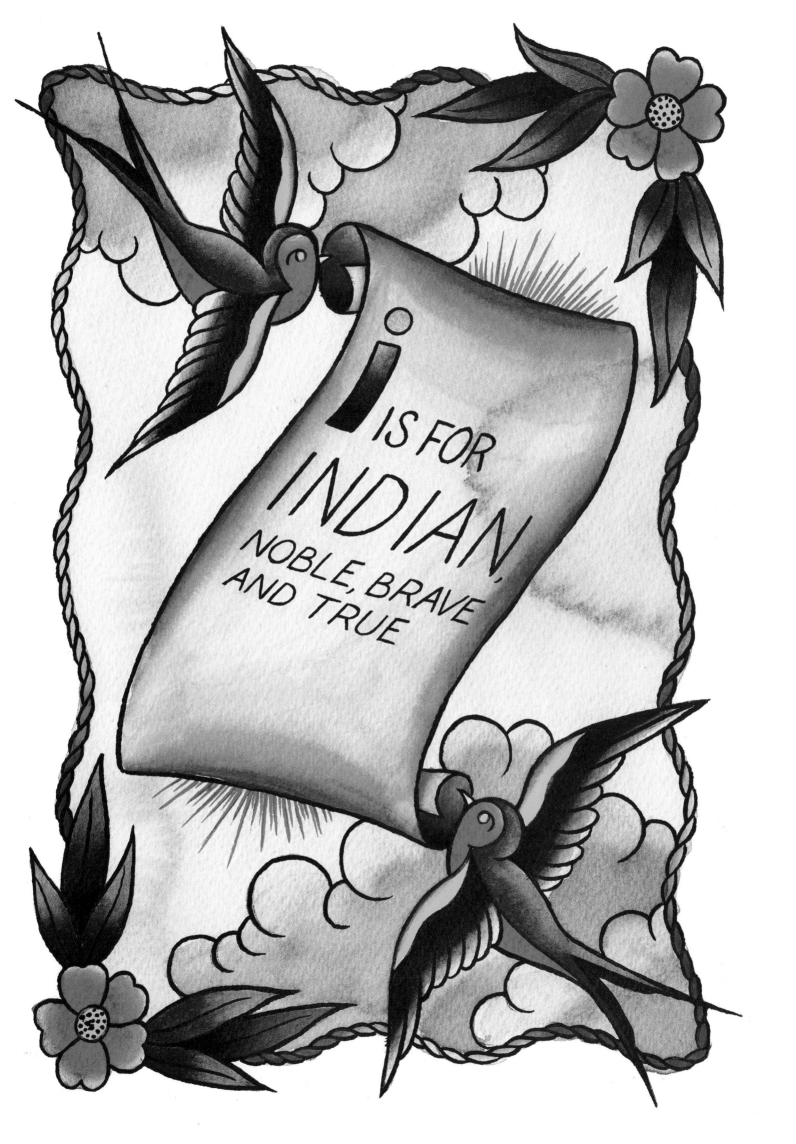

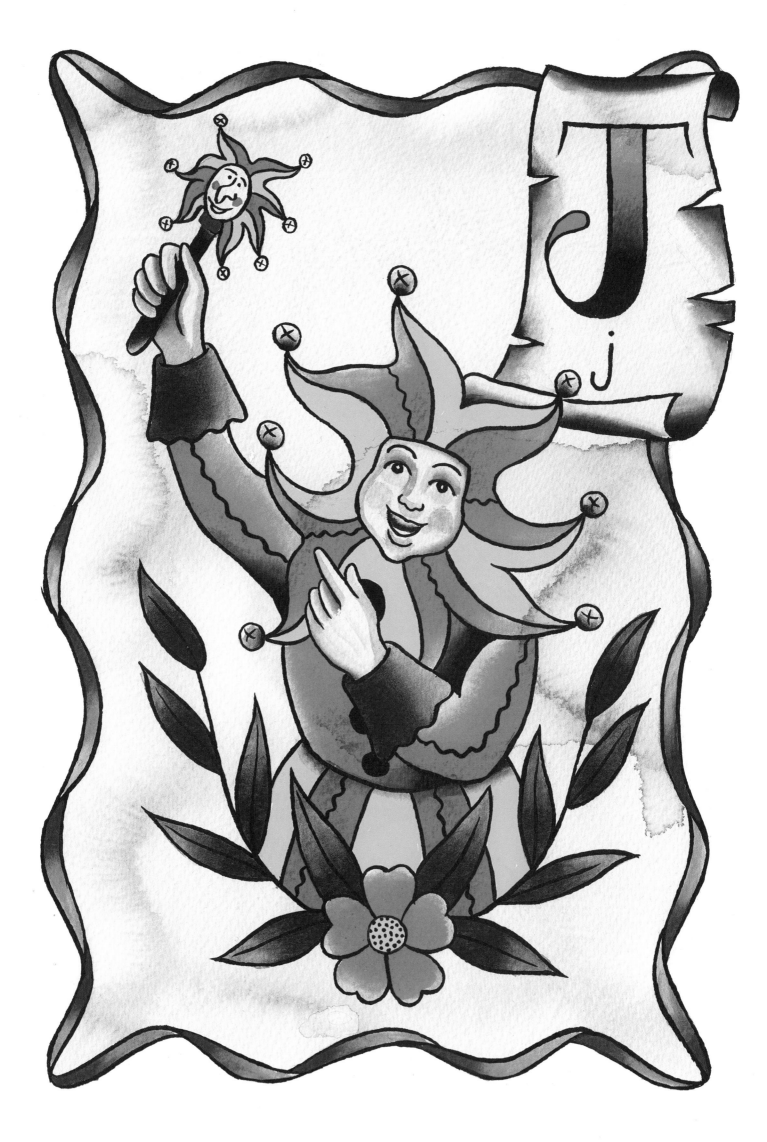

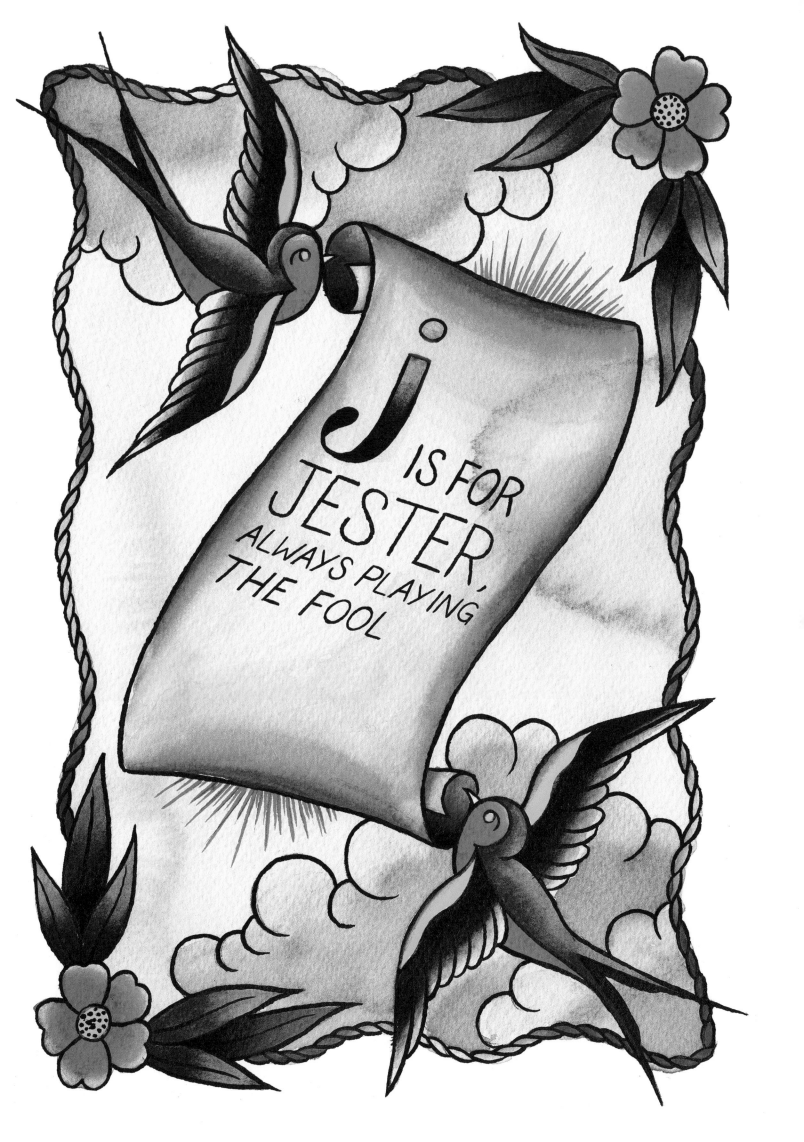

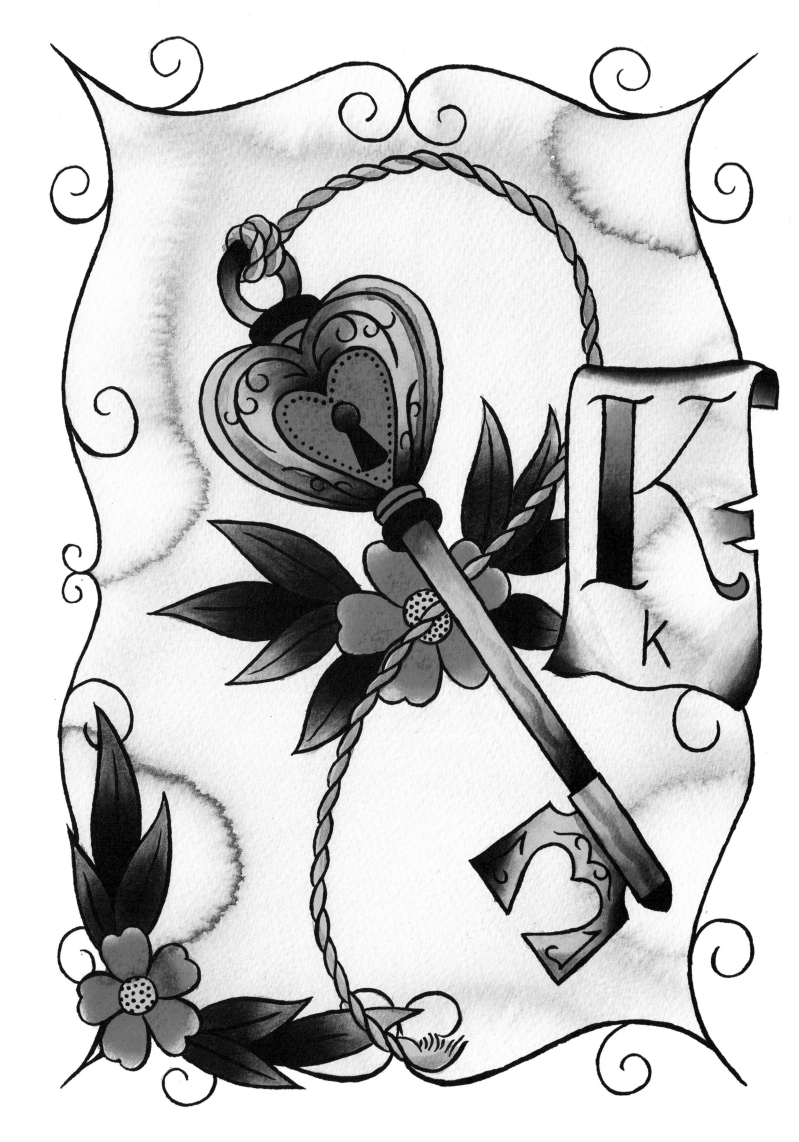

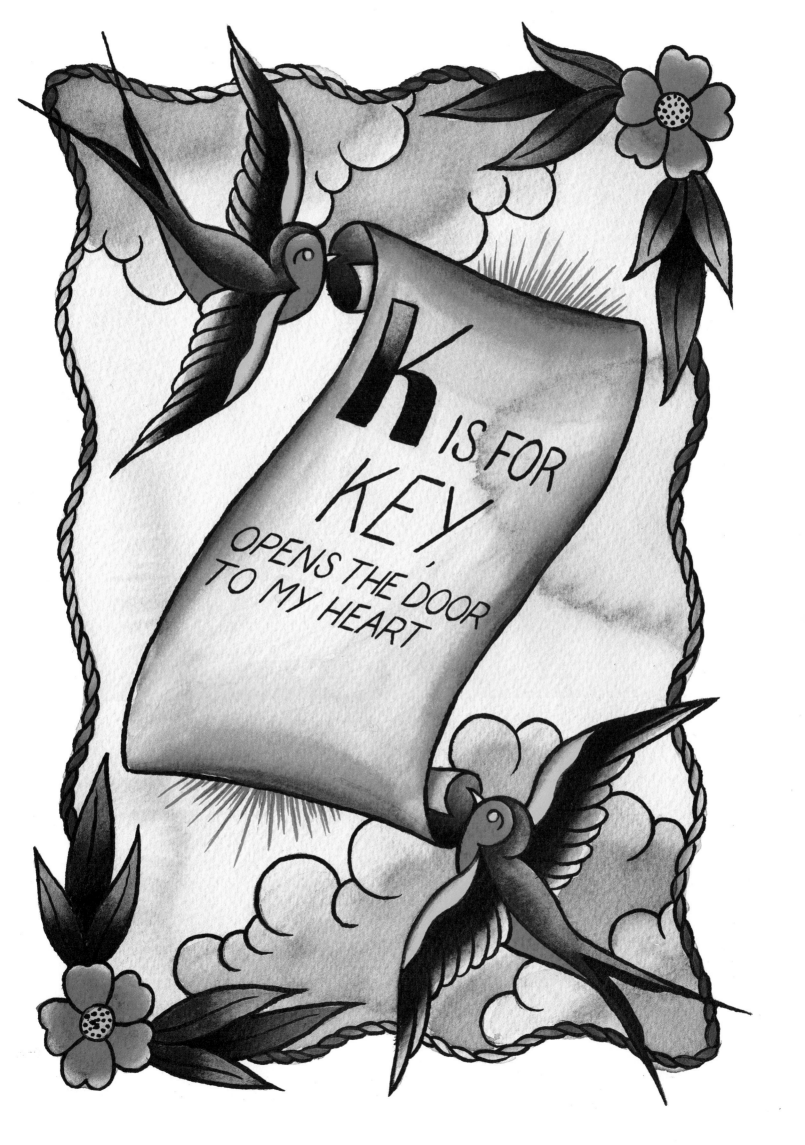

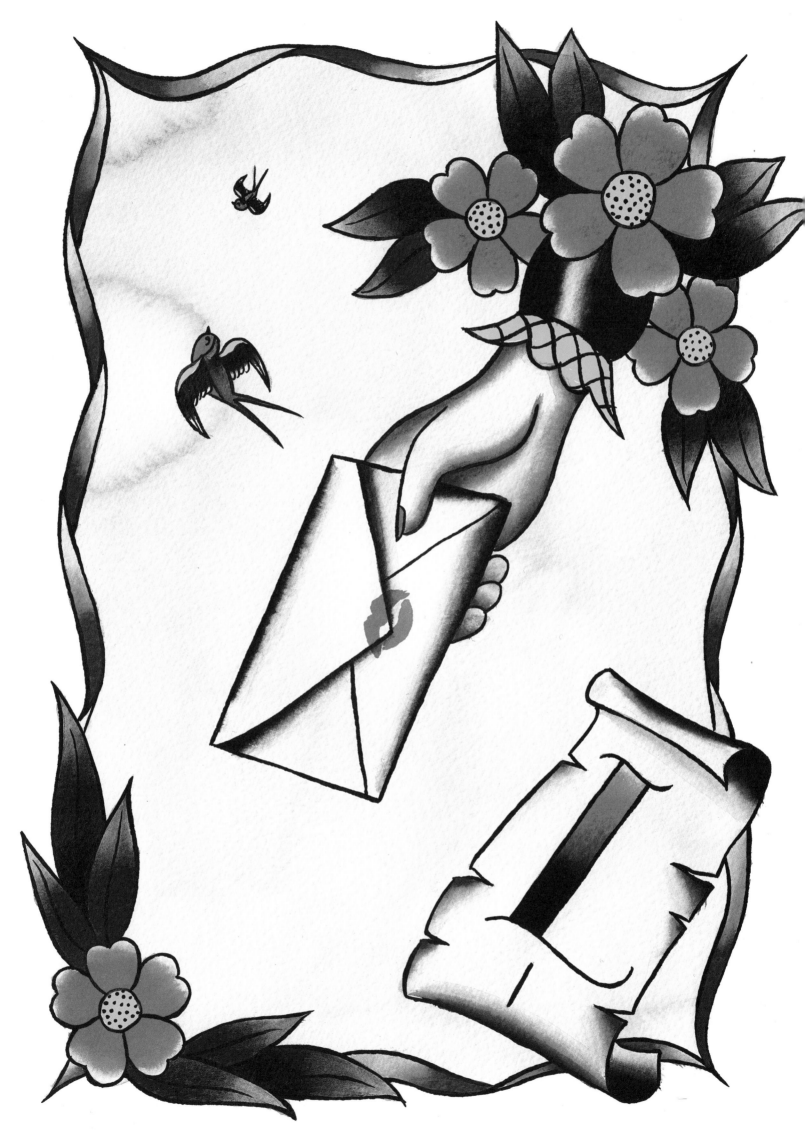

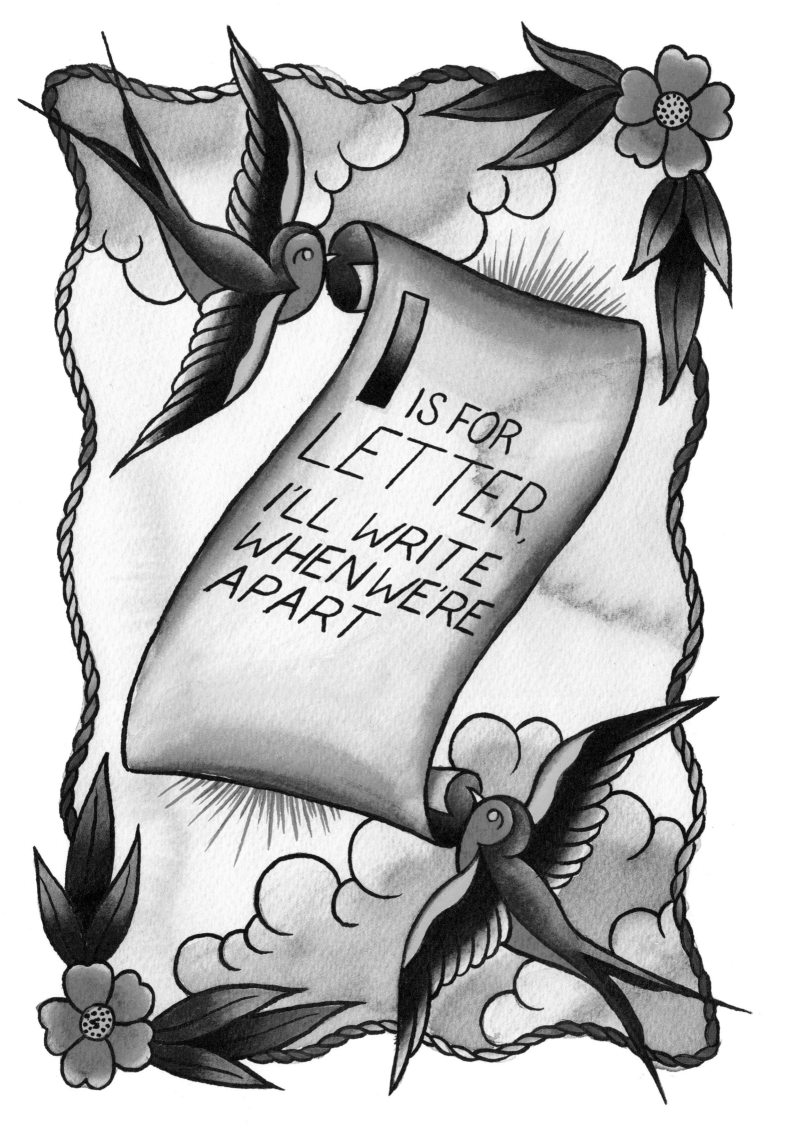

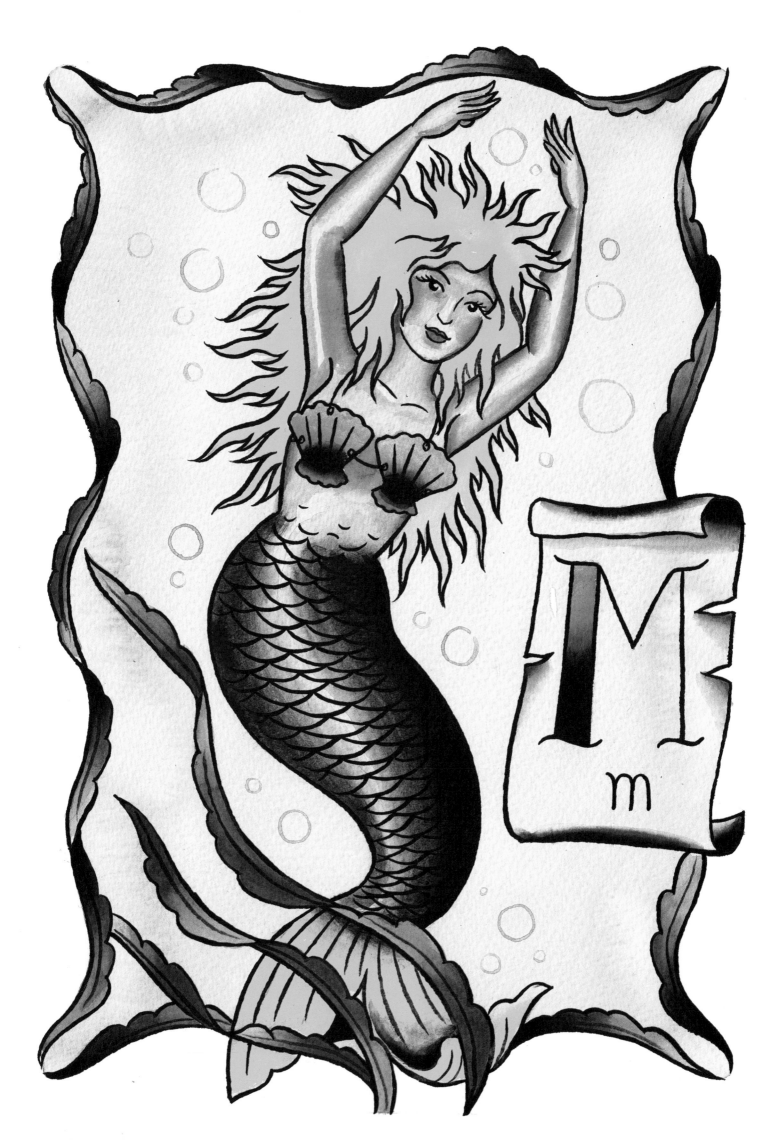

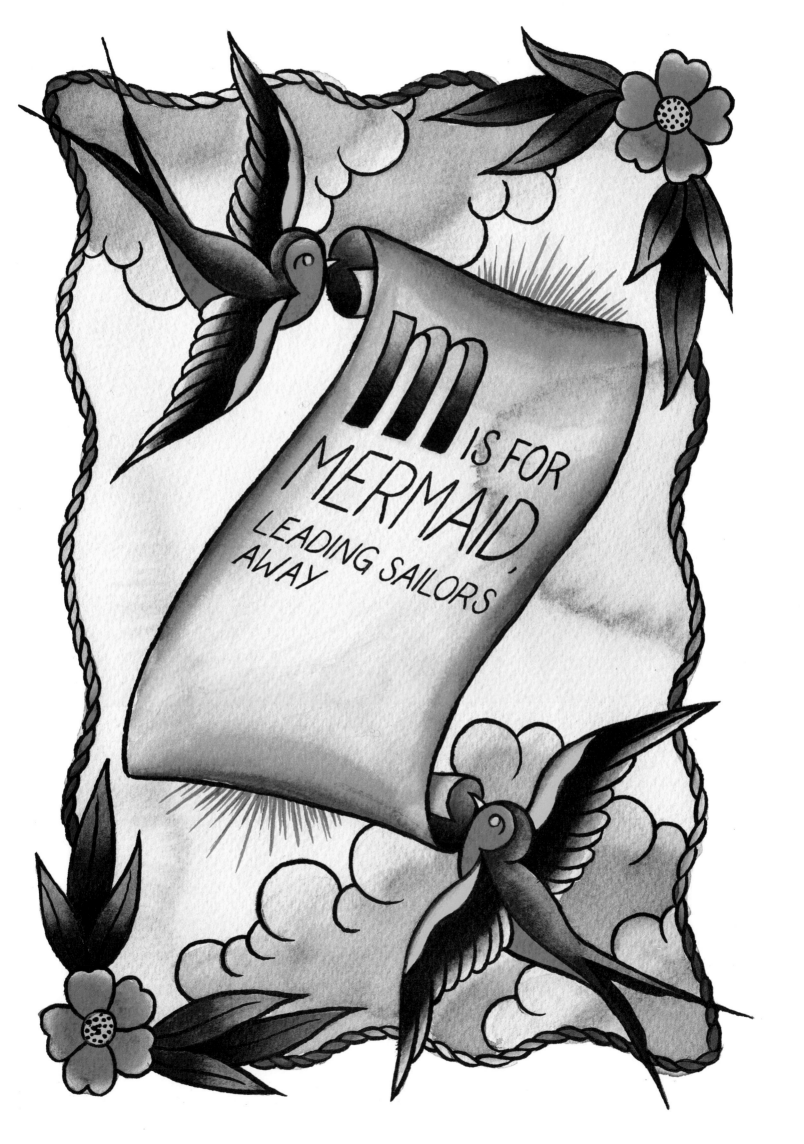

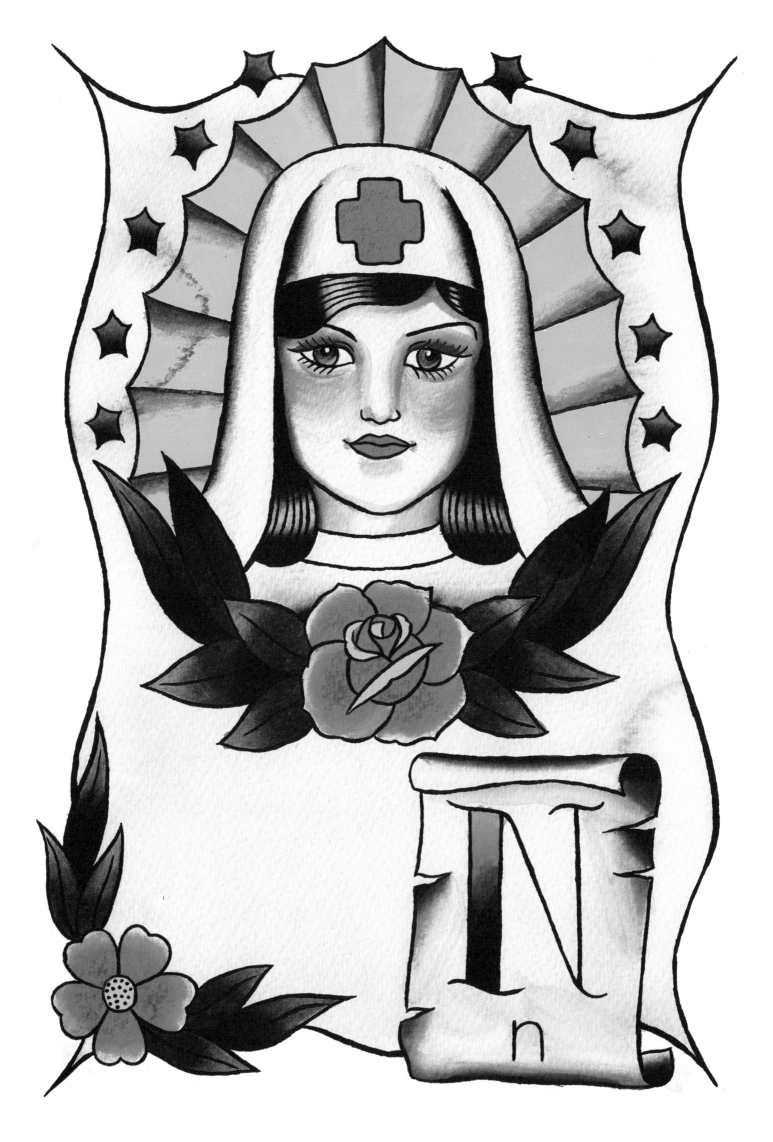

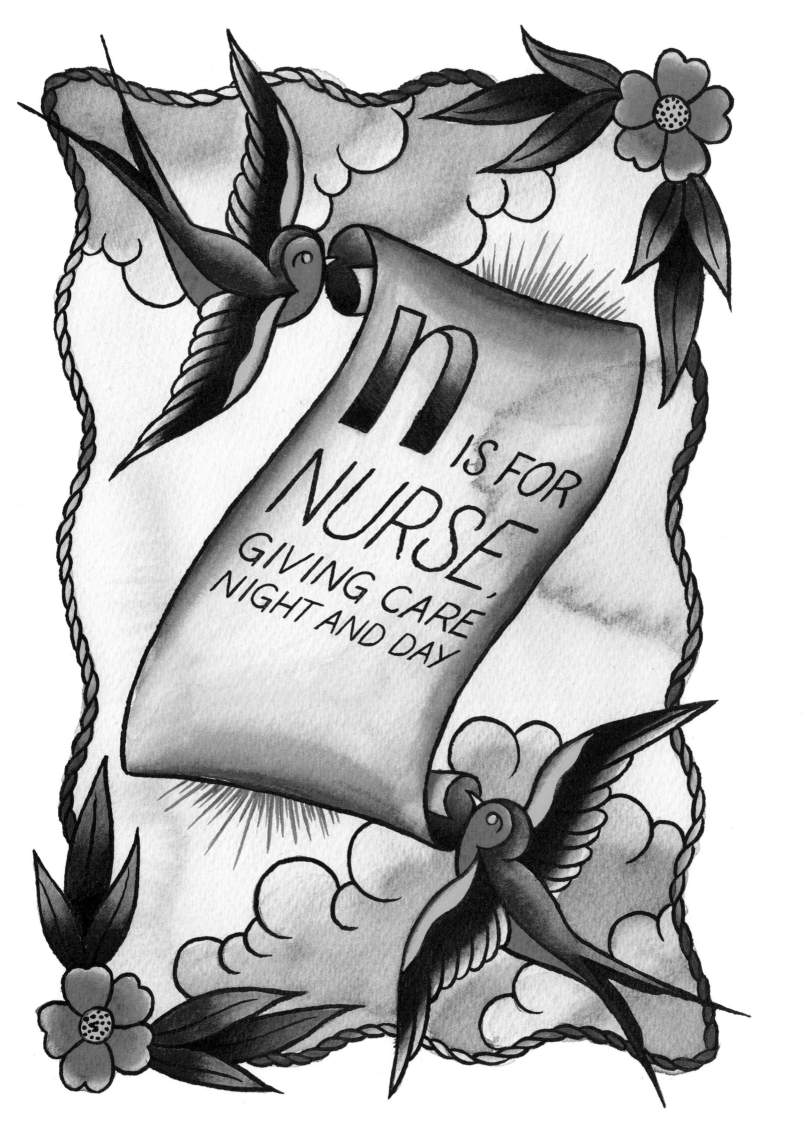

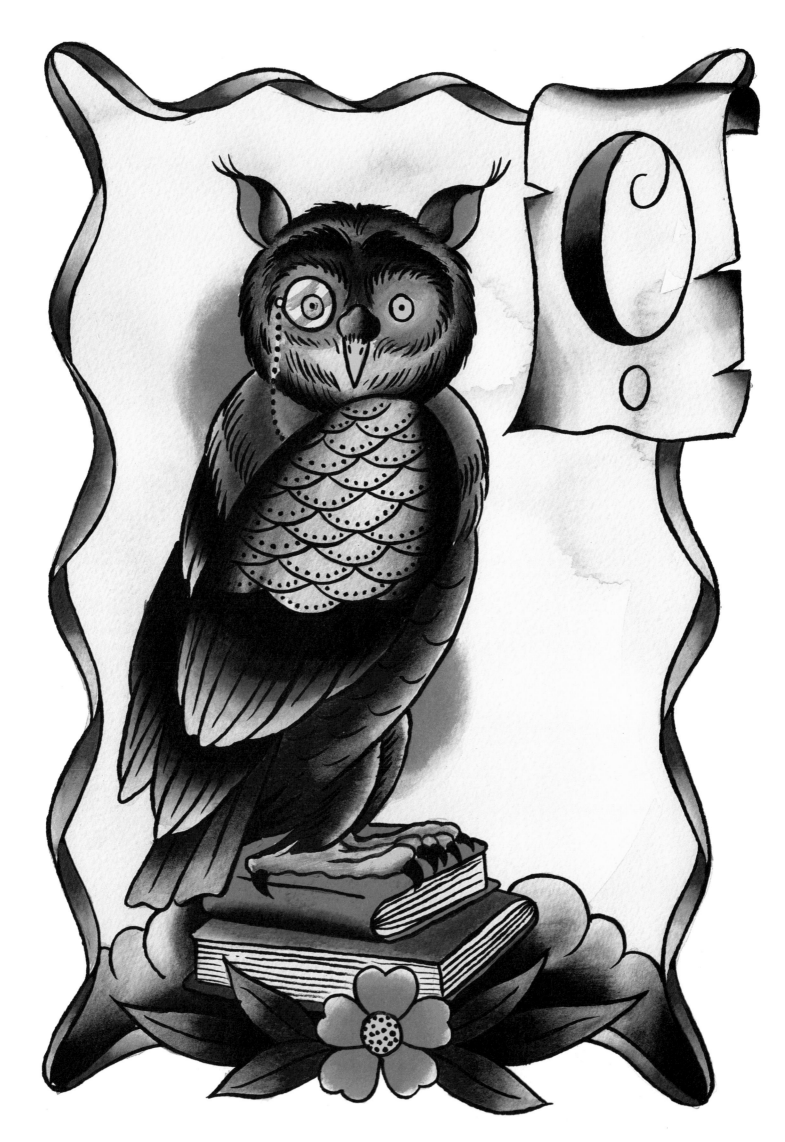

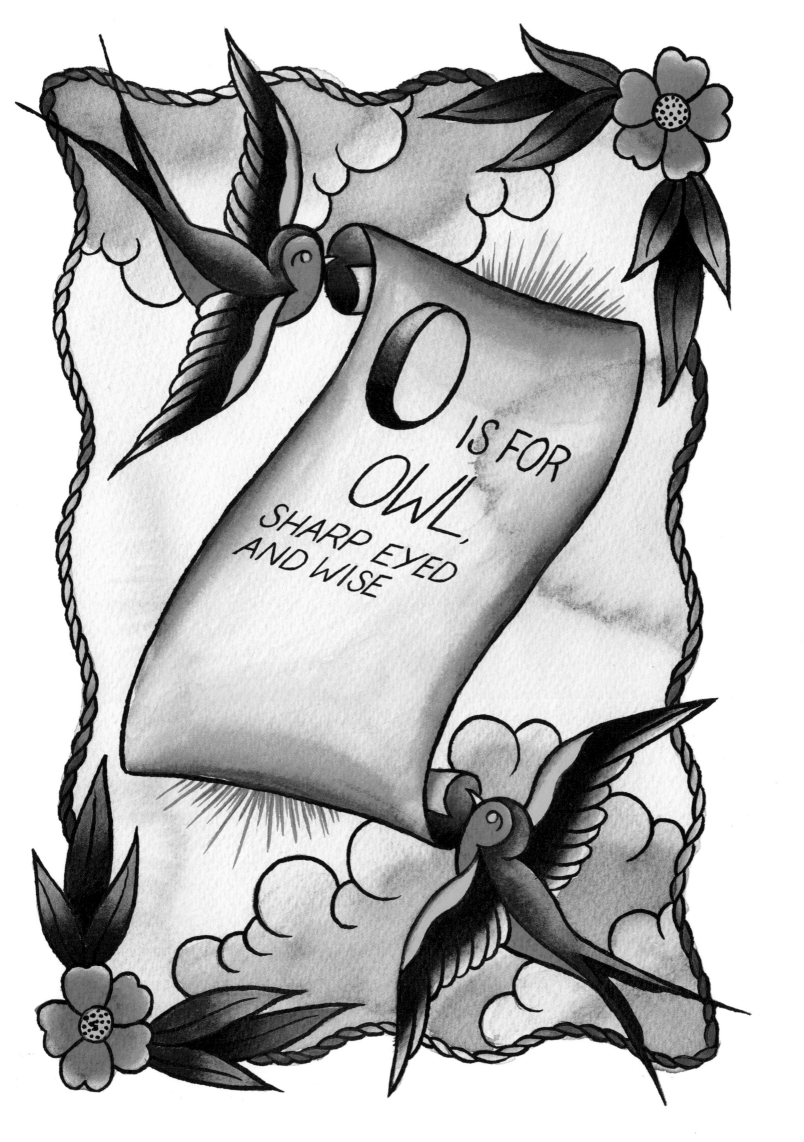

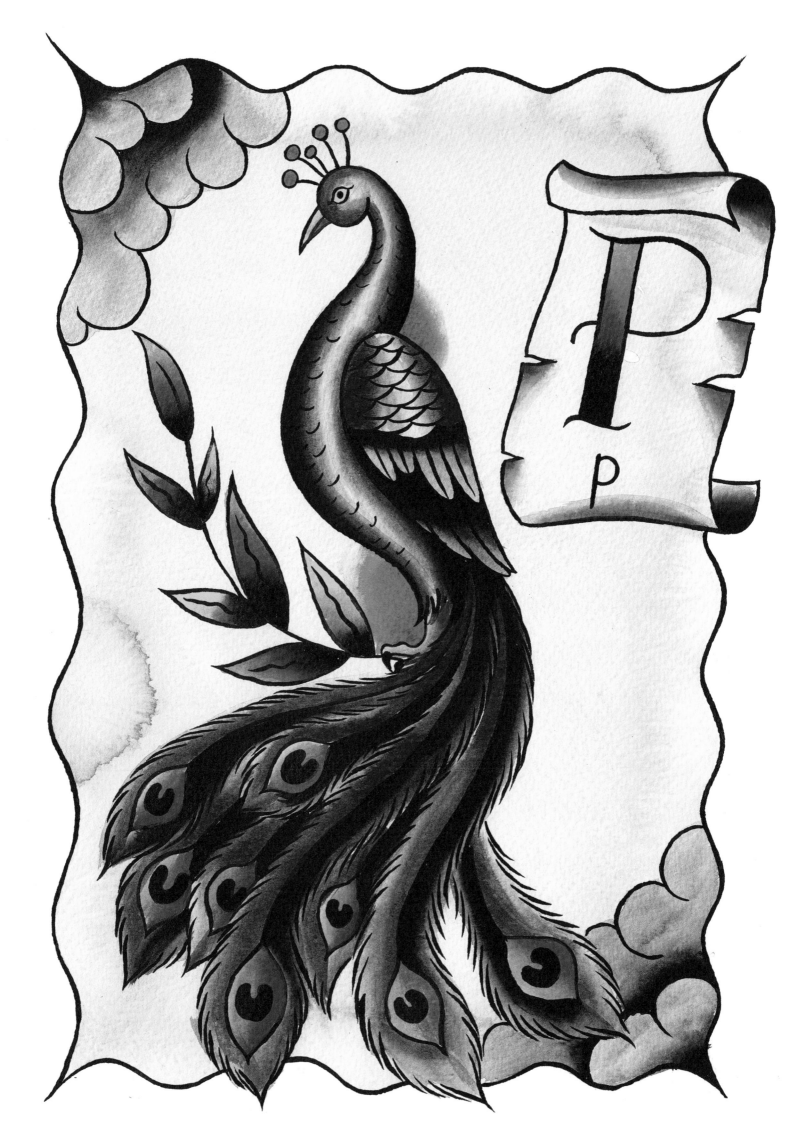

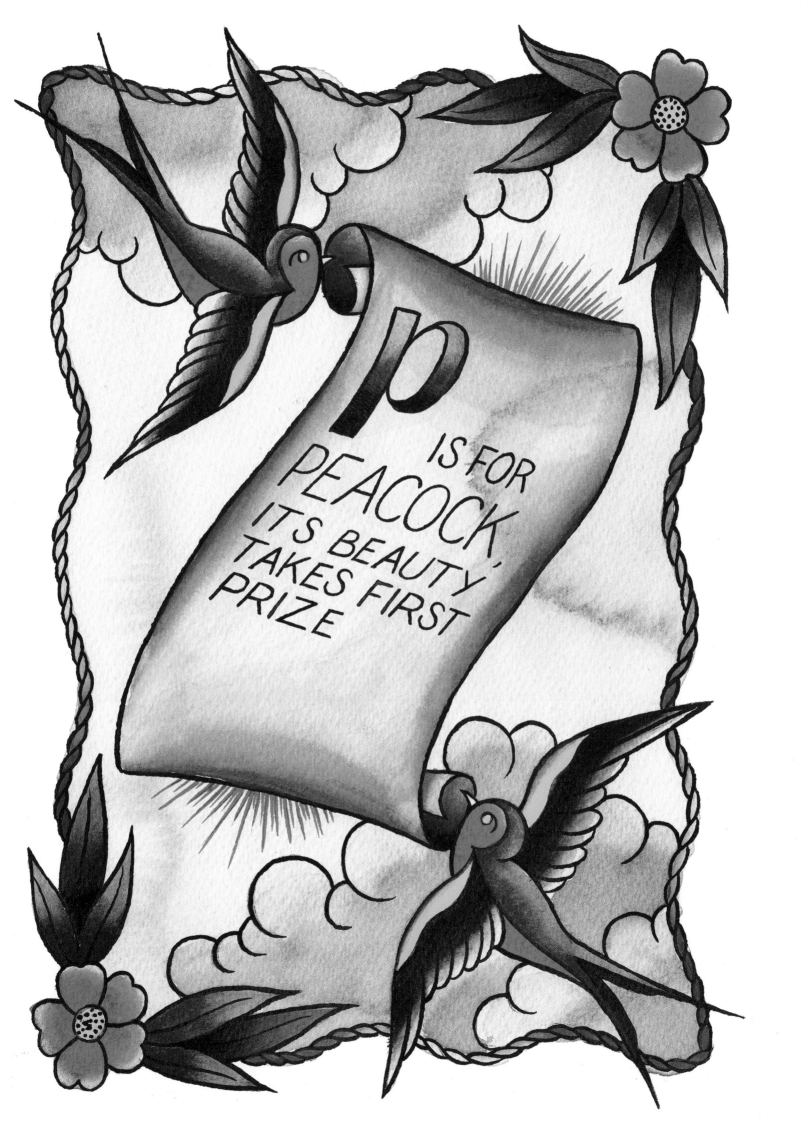

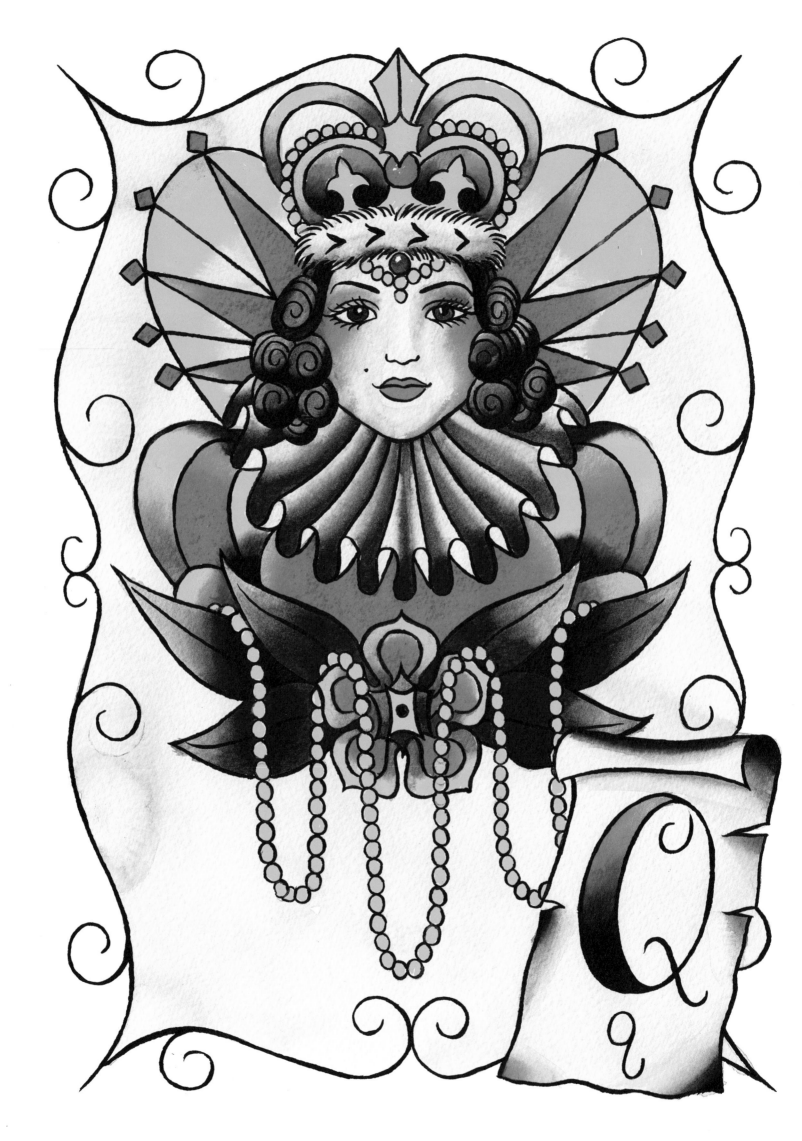

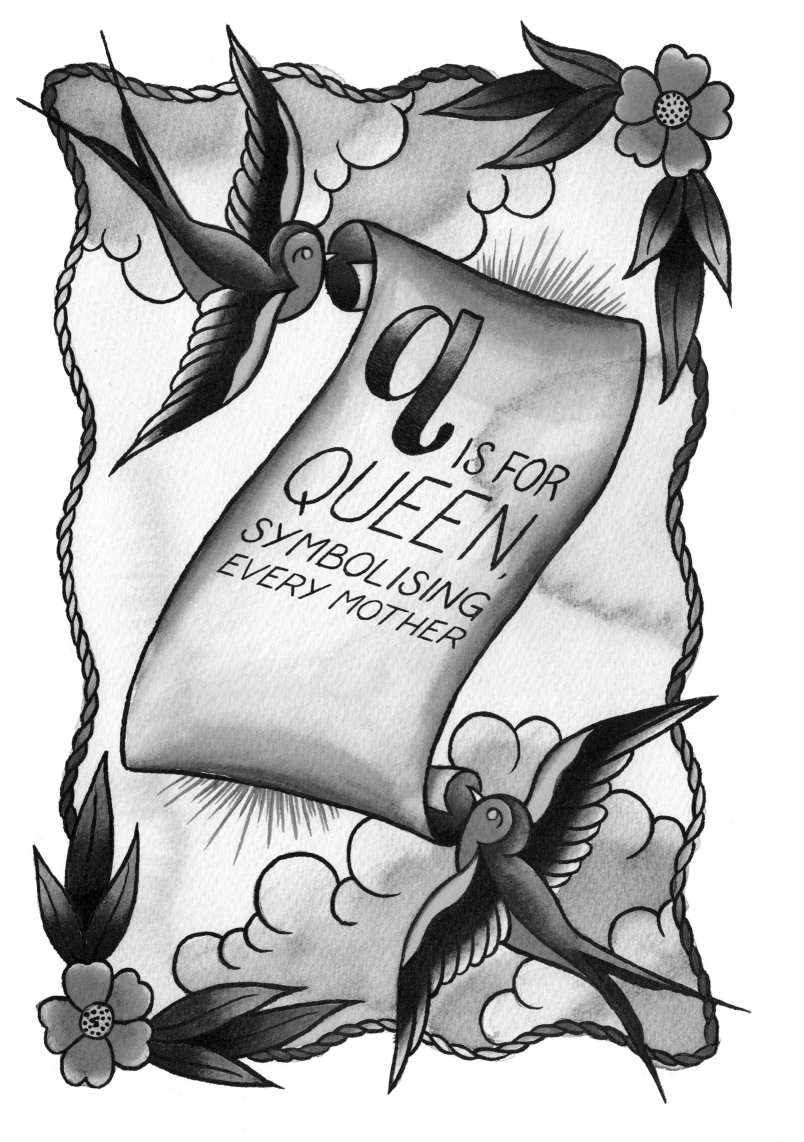

q IS FOR QUEEN, SYMBOLISING EVERY MOTHER

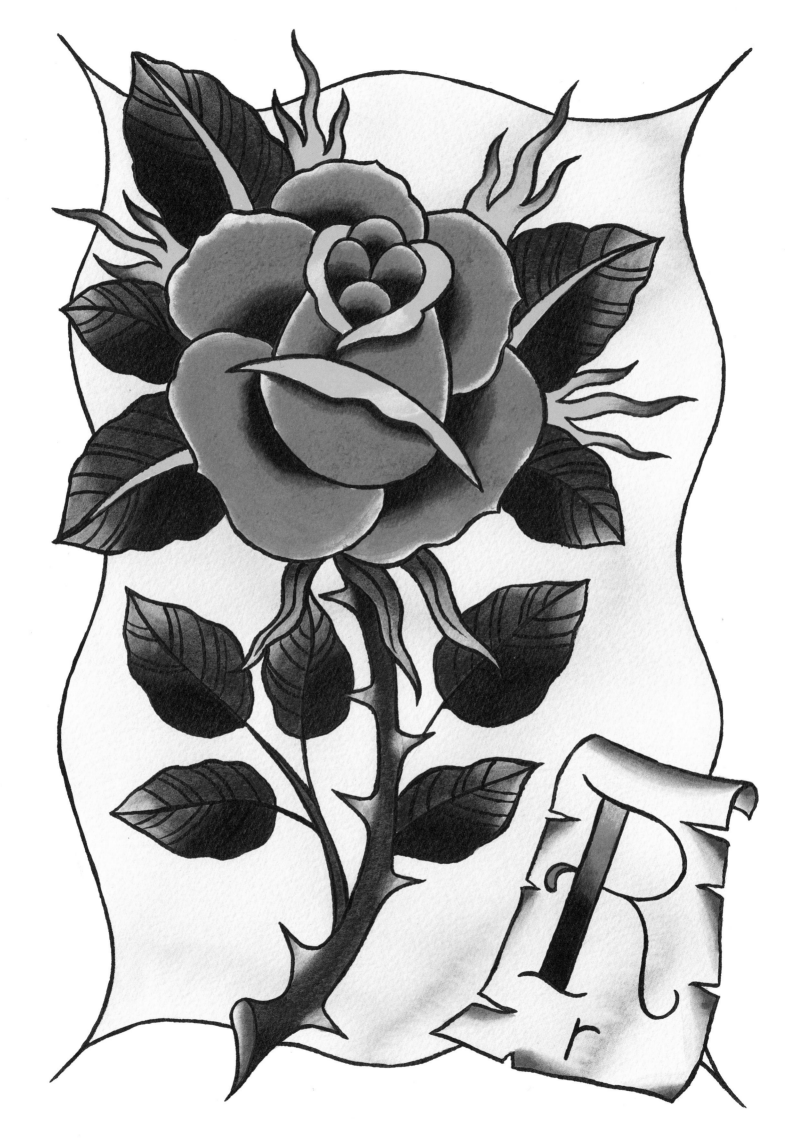

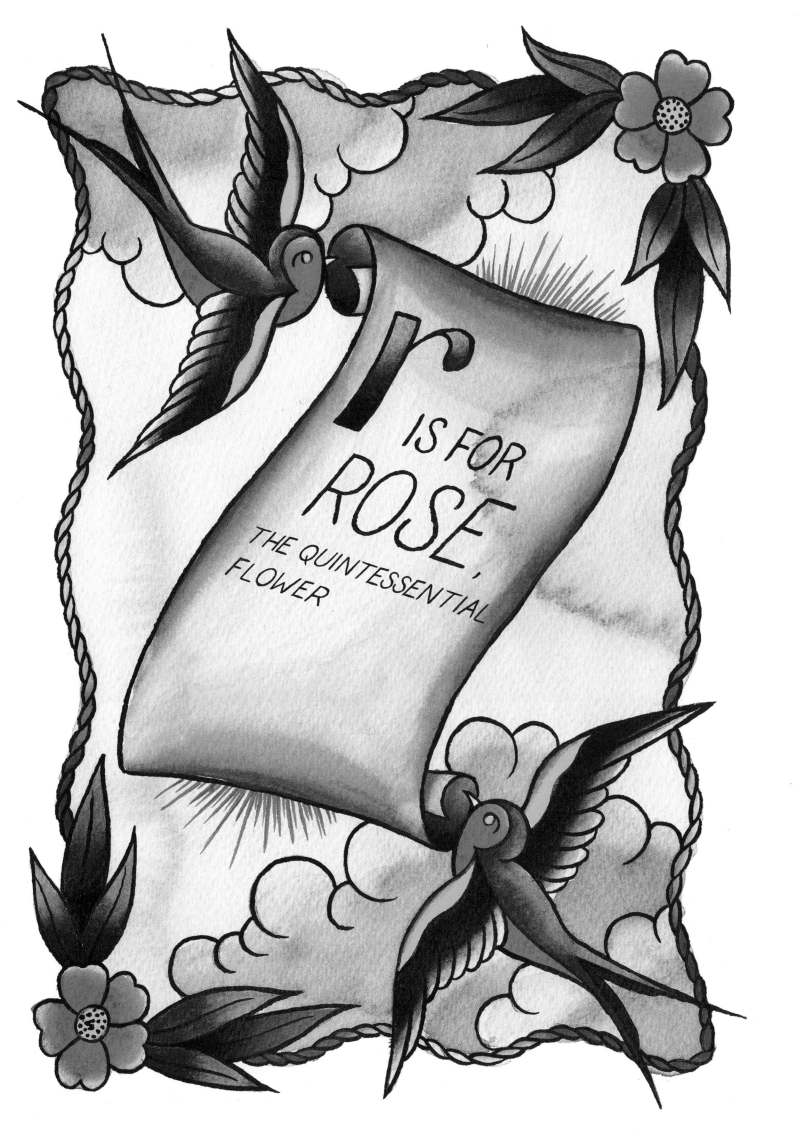

r IS FOR ROSE, THE QUINTESSENTIAL FLOWER

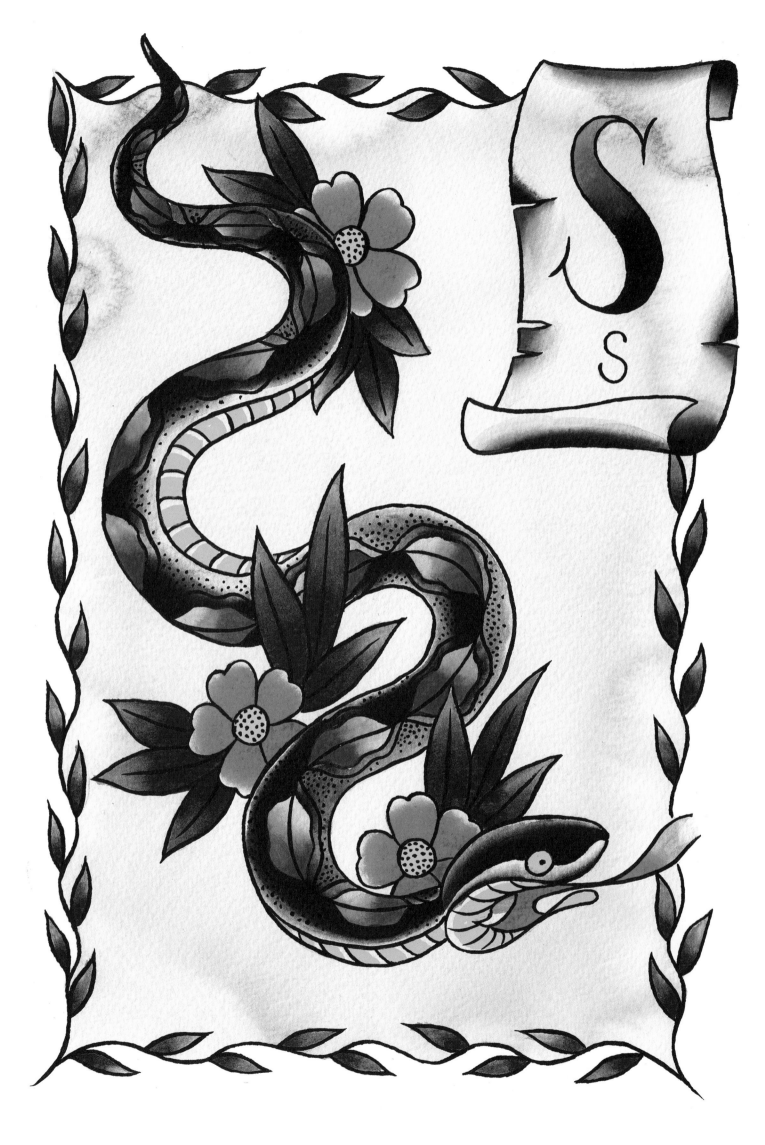

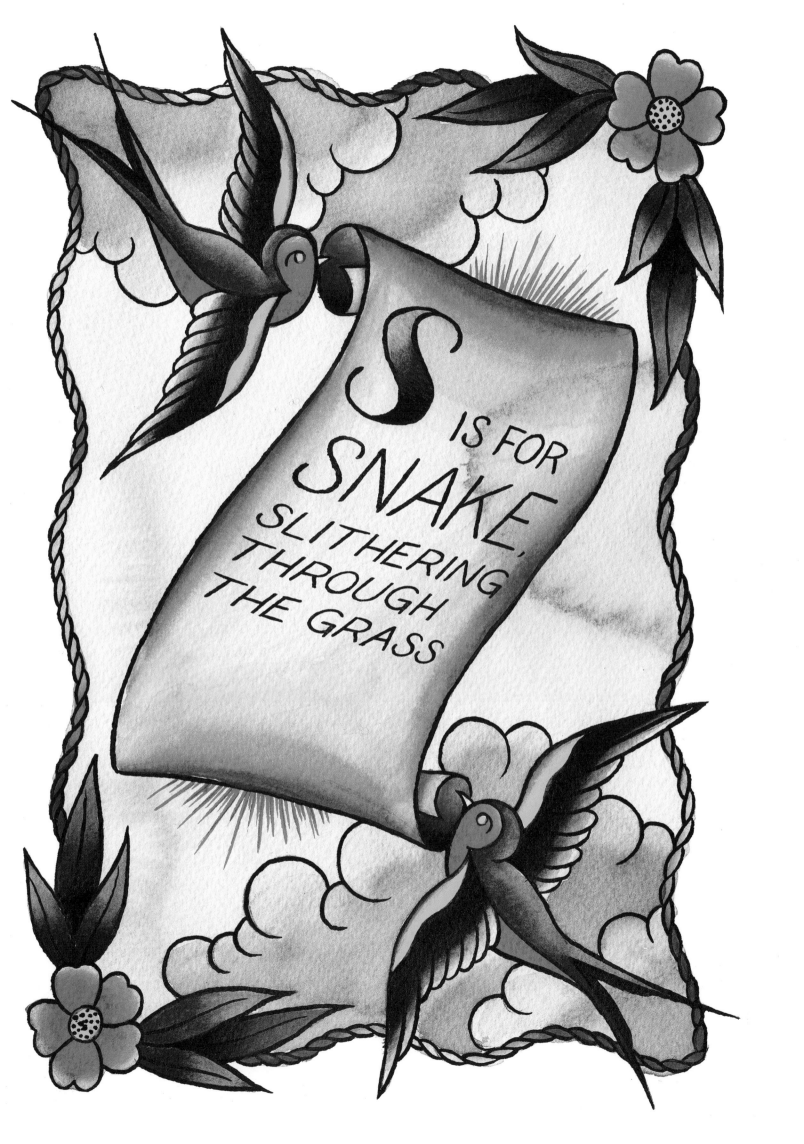

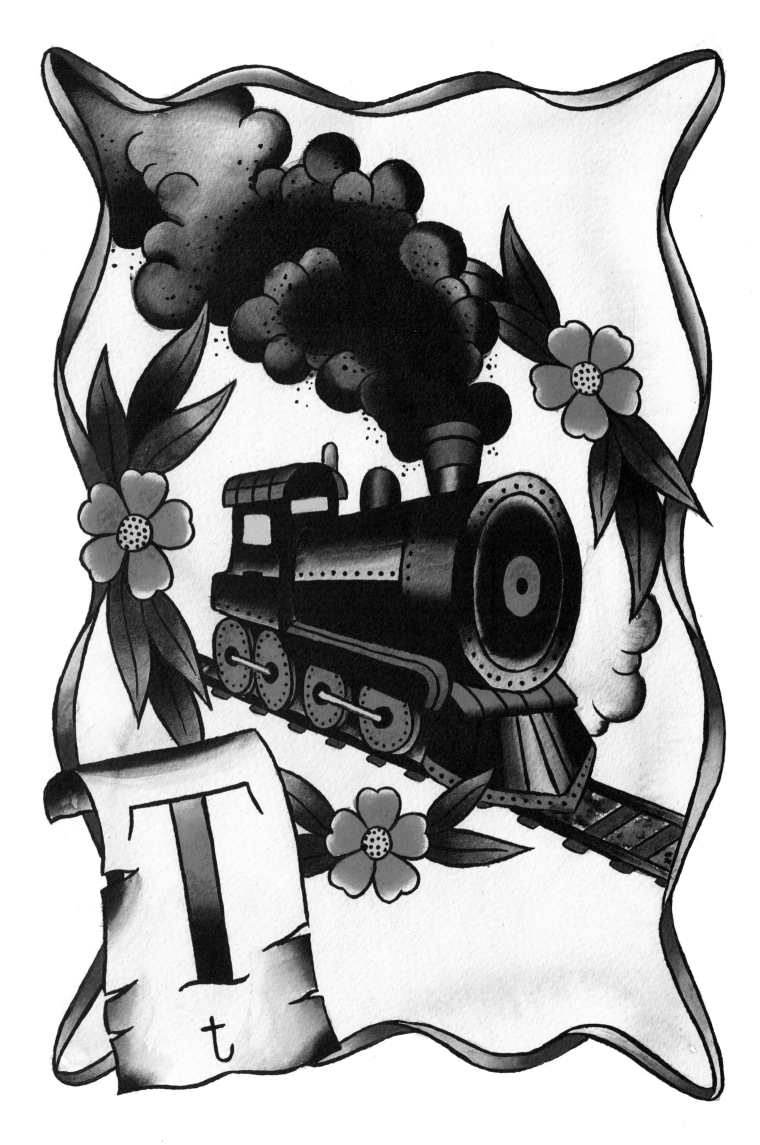

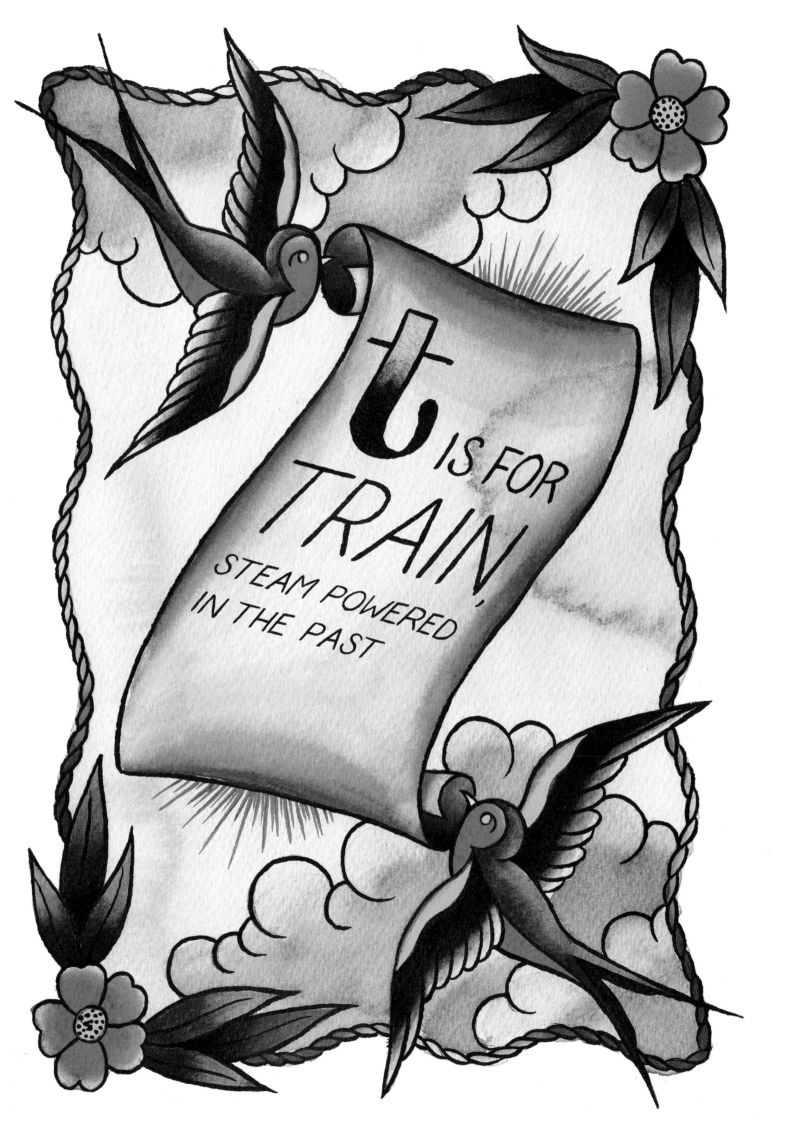

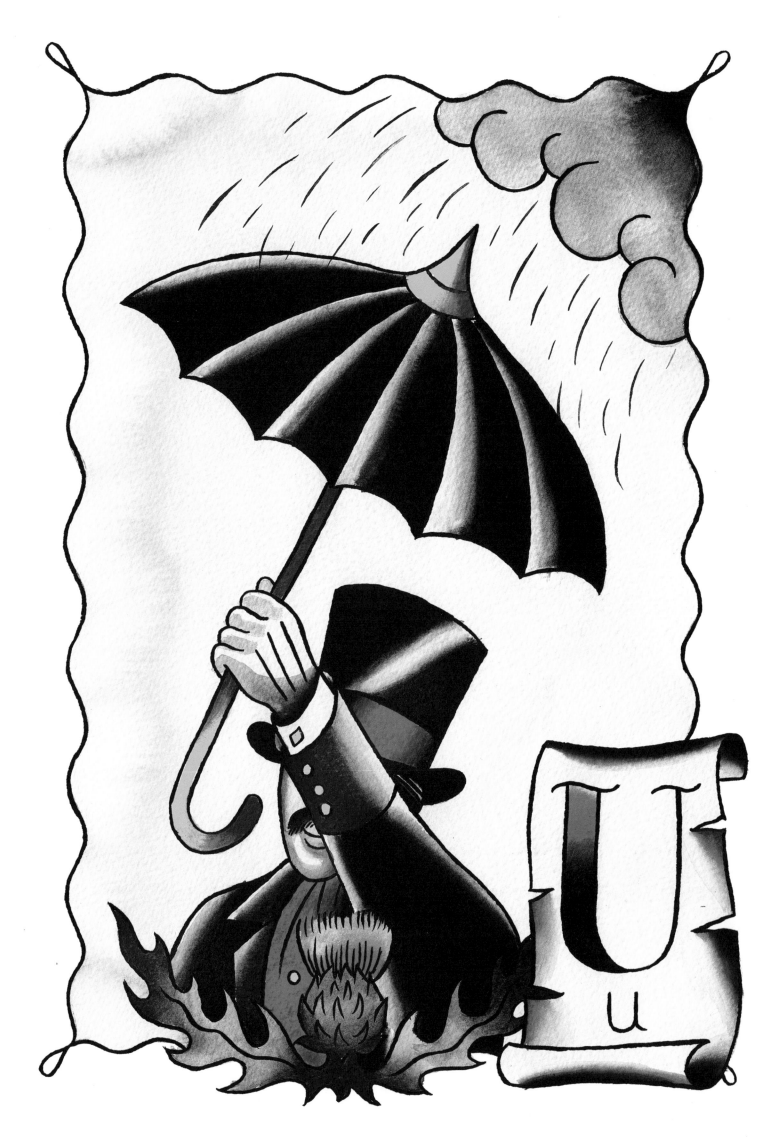

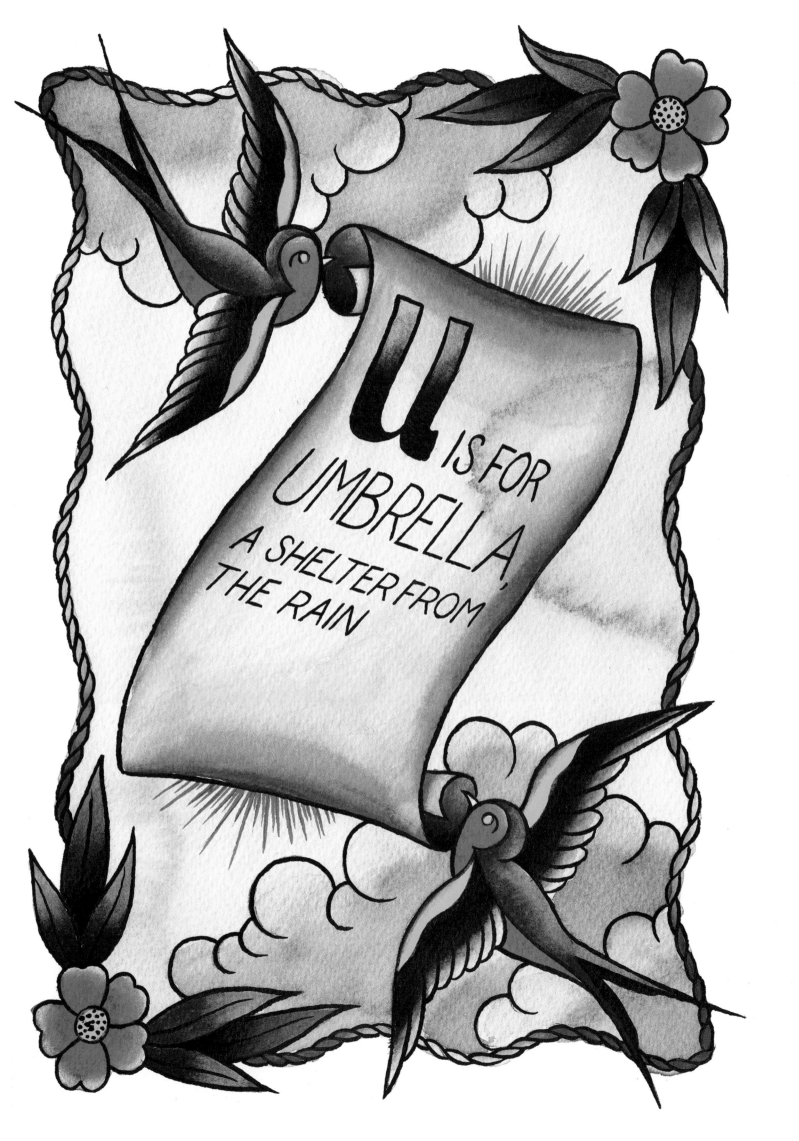

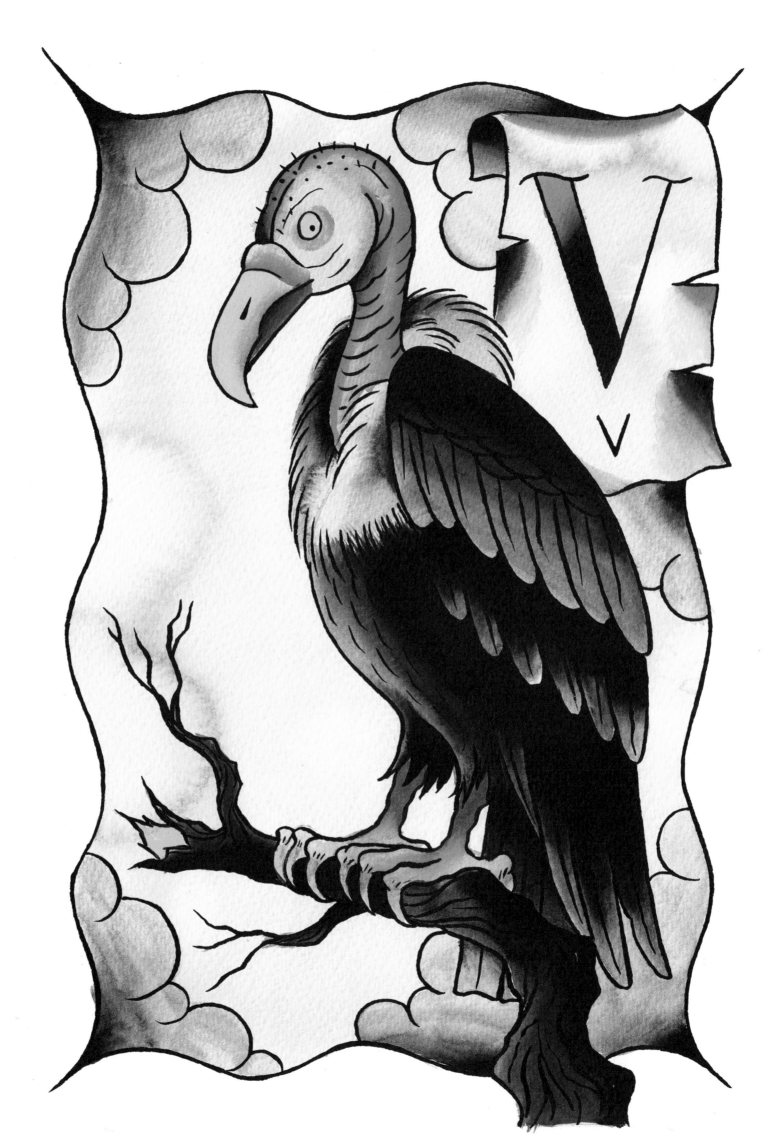

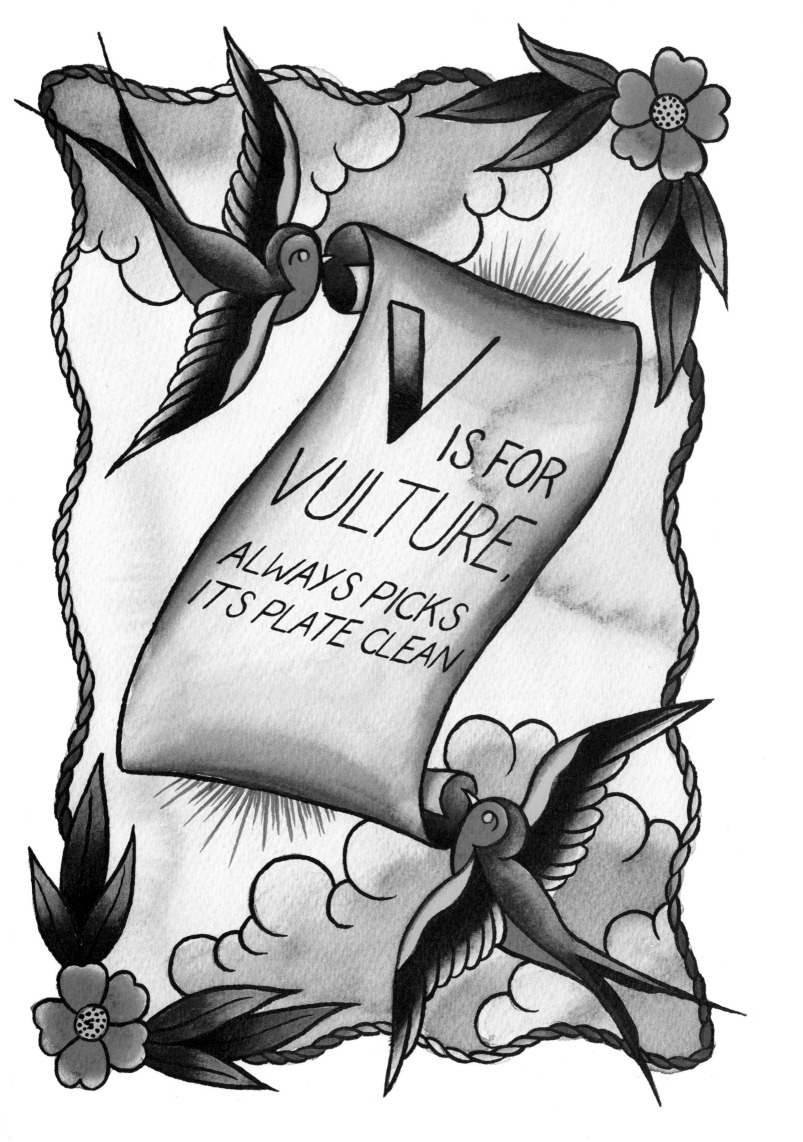

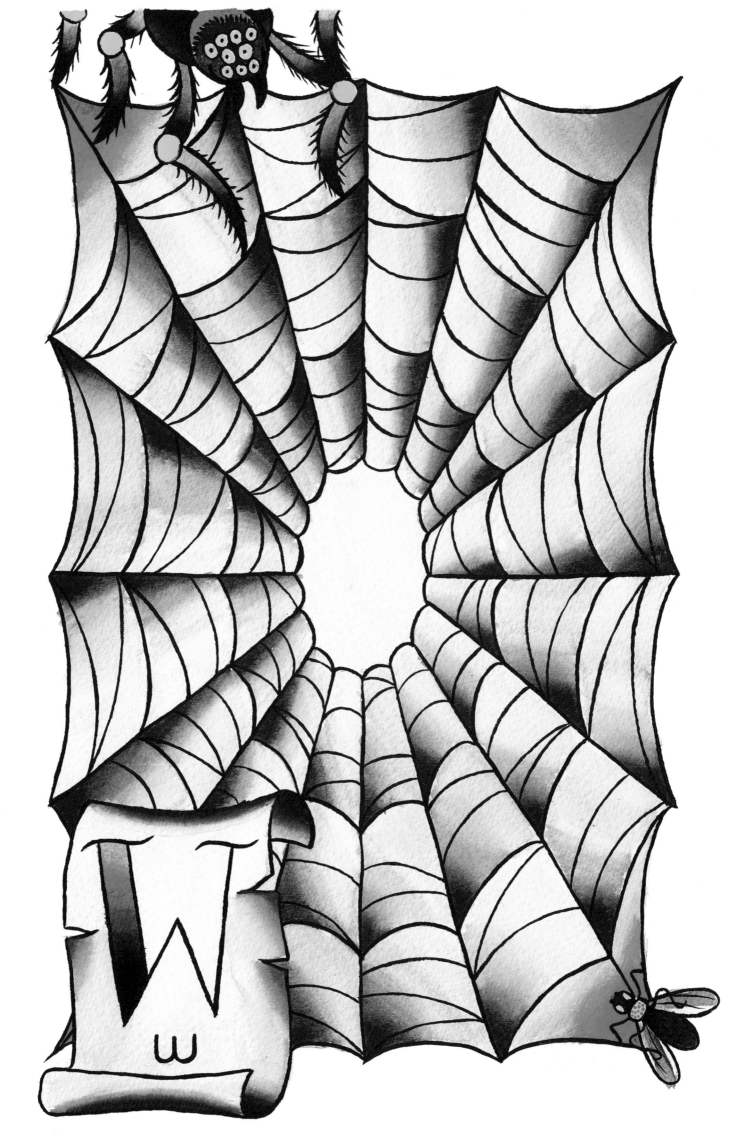

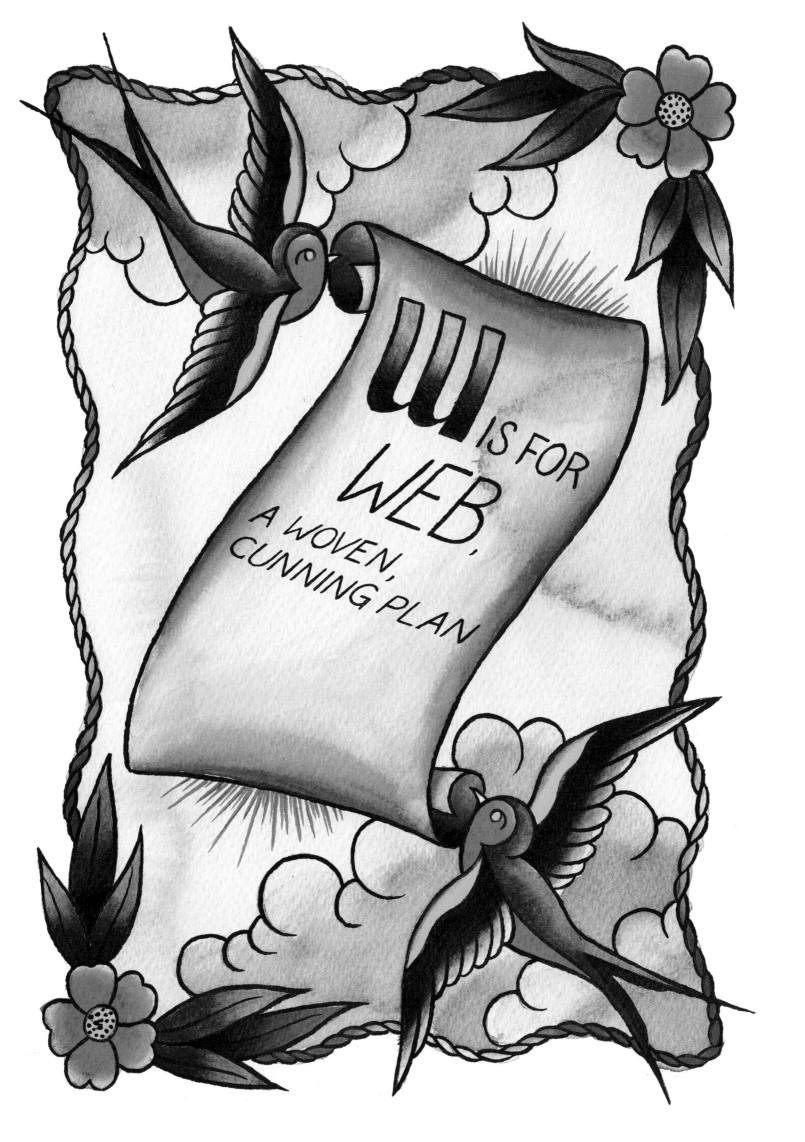

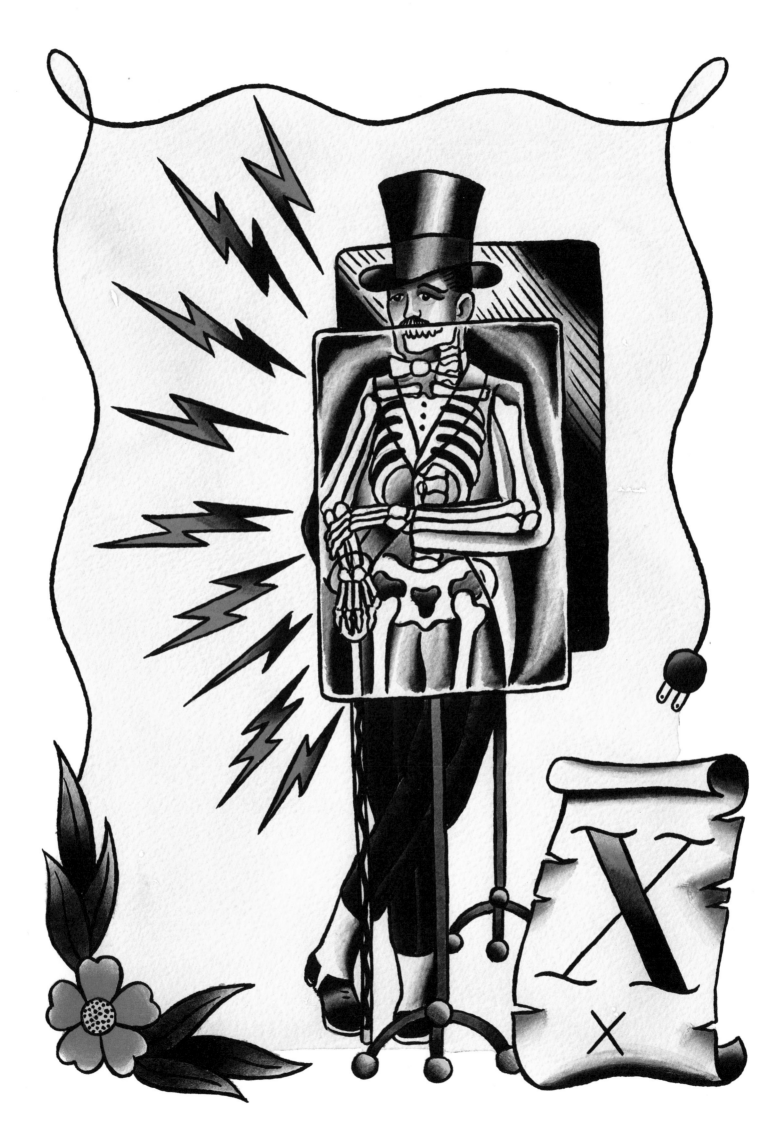

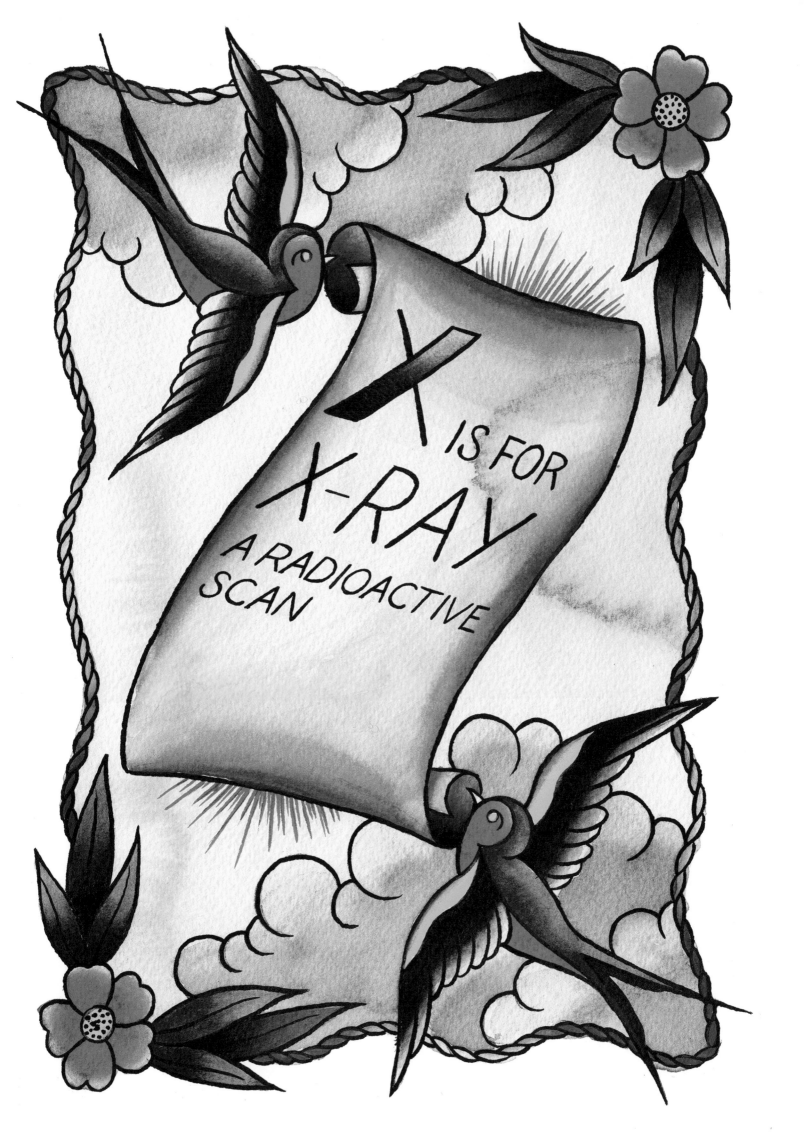

X IS FOR
X-RAY
A RADIOACTIVE
SCAN

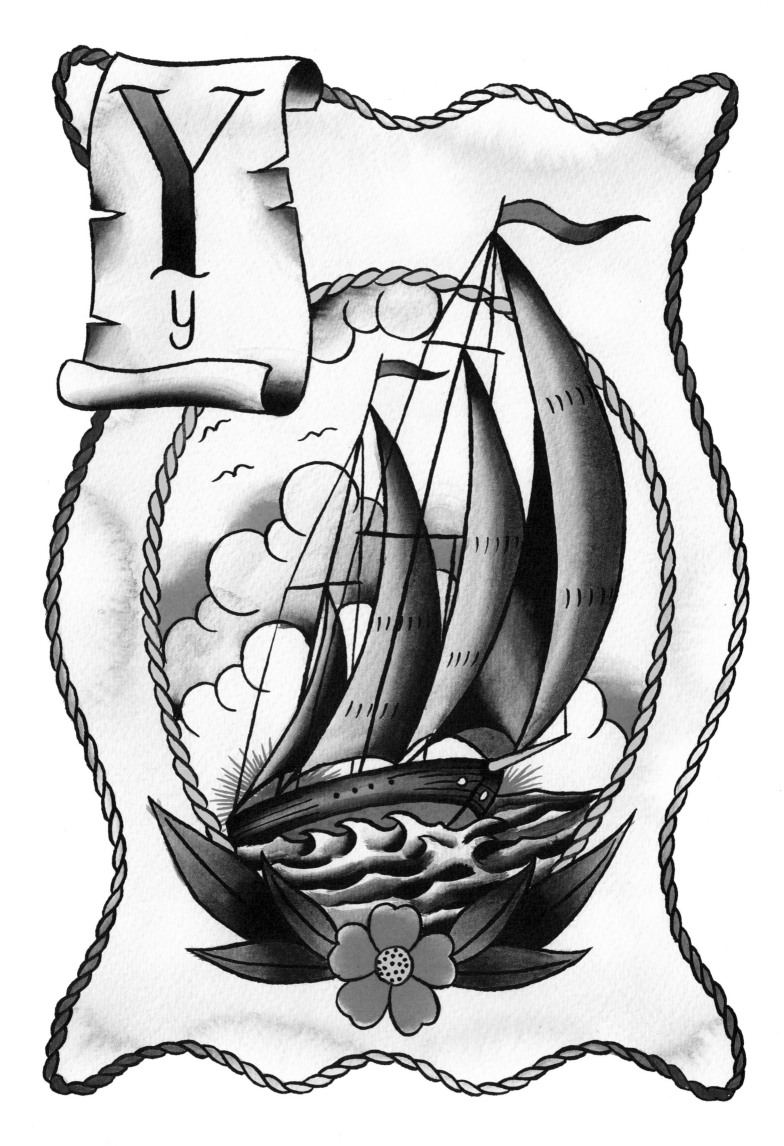

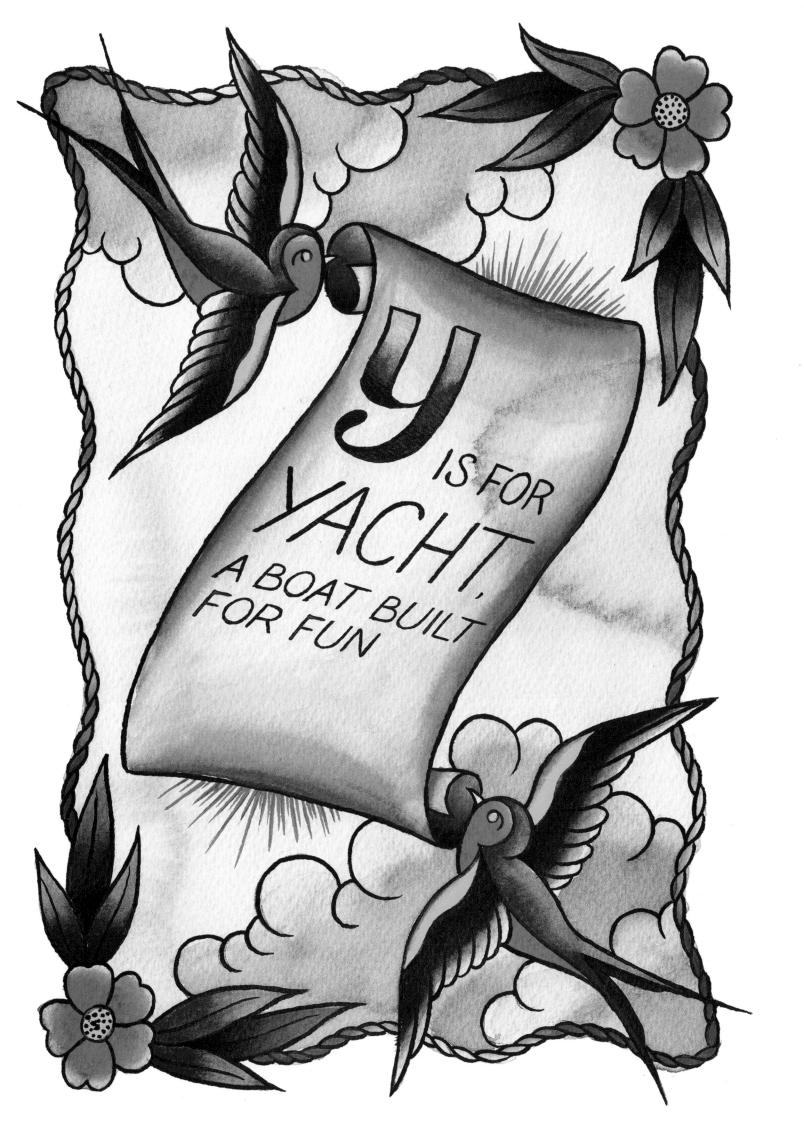

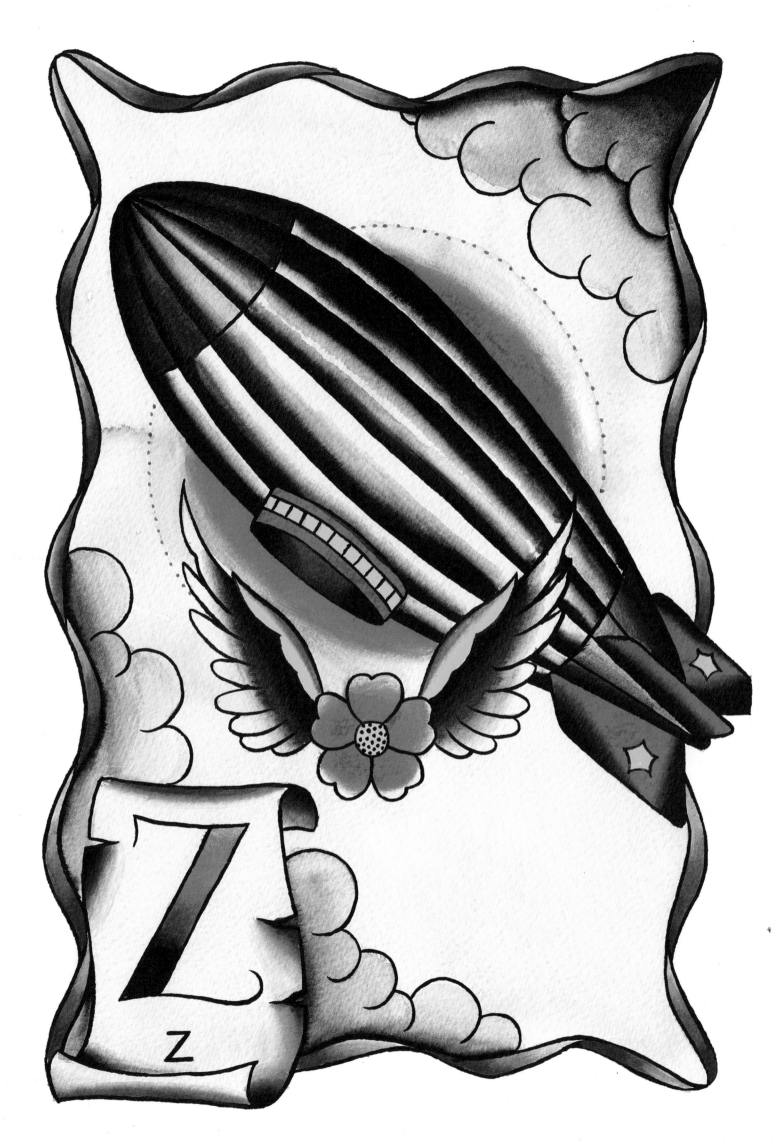

Z